J 143 Ame Ph

BOOKS IN THIS SERIES

- Draw 50 Airplanes, Aircraft, and Spacecraft
- Draw 50 Animals
- Draw 50 Athletes
- Draw 50 Beasties and Yugglies and Turnover Uglies and Things That Go Bump in the Night
- Draw 50 Boats, Ships, Trucks, and Trains
- Draw 50 Buildings and Other Structures
- Draw 50 Cars, Trucks, and Motorcycles
- Draw 50 Cats
- Draw 50 Creepy Crawlies
- Draw 50 Dinosaurs and Other Prehistoric Animals
- Draw 50 Dogs
- Draw 50 Endangered Animals
- Draw 50 Famous Caricatures
- Draw 50 Famous Cartoons
- Draw 50 Famous Faces
- Draw 50 Flowers, Trees, and Other Plants
- Draw 50 Holiday Decorations
- Draw 50 Horses
- Draw 50 Monsters, Creeps, Superheroes, Demons, Dragons, Nerds, Dirts, Ghouls, Giants, Vampires, Zombies, and Other Curiosa . . .
- Draw 50 People
- Draw 50 People of the Bible
- Draw 50 Sharks, Whales, and Other Sea Creatures
- Draw 50 Vehicles

Lee J. Ames with Creig Flessel

DOUBLEDAY

NEW YORK LONDON TORONTO SYDNEY AUCKLAND

A MAIN STREET BOOK
PUBLISHED BY DOUBLEDAY
a division of Bantam Doubleday Dell Publishing Group, Inc.
1540 Broadway, New York, New York 10036

MAIN STREET BOOKS, DOUBLEDAY, and the portrayal of a building with a tree are trademarks of Doubleday, a division of Bantam Doubleday Dell Publishing Group, Inc.

Draw 50 People was previously published in hardcover by Doubleday in 1993. This Main Street Books edition is published by arrangement with Doubleday.

The Library of Congress has catalogued the Doubleday edition as follows:

Ames, Lee J.
Draw 50 people/Lee J. Ames with Creig Flessel.—1st ed.
p. cm.
1. Portrait drawing—Technique. I. Flessel, Creig. II. Title.
III. Title: Draw fifty people.
NC773.A46 1993
743'.4—dc20

ISBN 0-385-41194-4 Copyright © 1993 by Lee J. Ames and Murray D. Zak All Rights Reserved Printed in the United States of America FIRST MAIN STREET BOOKS EDITION: September 1994

10 9 8 7 6

We, Creig and Lee,
raise a toast,
a Berndt Toast,
to a prince among people,
Chuck Harriton,
who will be sorely missed.

Author's Note

I have known, respected, and admired Creig for over thirty years. In our Berndt Toast Gang, the largest branch of the National Cartoonist's Society, Creig, our leader, whom we have dubbed "The Infallible," and whose light, bright, and lusty drawings have enchanted us for decades, offers these thoughts . . .

Writers, critics, and artists have for aeons tried to describe and explain drawing. They have written: "He's a great draughtsman"; "He draws with calligraphic verve"; ". . . a linear delight with a personal, exciting line." Etcetera, etcetera.

What do they mean?

Picasso, Ingres, and Mary Cassatt were great draughtspersons, but were all very different. John Singer Sargent's delightful calligraphic brush strokes were exciting. Picasso's line was honest. The art of drawing has been analyzed, dissected, and even "Freudianized" through the ages by expert and dilettante critics. So let's get personal and get to the basics: What is a drawing?

Our tools can be pencil, pen, charcoal, pastel, a computer, and, of course, the right side of the brain.

In art school in 1932, my instructor was the legendary Harvey Dunn, a mountain of a man who used a two-inch-wide brush. He used his drawing skill by daubing the paint on his canvas in a thick impasto. He blended his shapes and colors by twirling his brush in the heavy paint. We stood in awe and murmured, "Some draughtsman! Wow!"

Mario Cooper, our class monitor, used colored inks, photographs, and water-colors to produce his fine slick illustrations. He later earned an outstanding reputation as one of our top magazine artists. "Great draughtsman," we murmured.

I soon found myself delighted with the work of giants like Noel Sickles, Al Dorne, Austin Briggs, Dik Browne, Stan Drake, Lou Fine, and Alex Kotsky. All great draughtsmen. The best!

Dik Browne's palette, when he was working on his comic strip "Hagar the Horrible," looked like Jackson Pollock's paint rags. His brushes were frayed.

His pens were thickly caked with India ink. But what a great draughtsman, he was!

In contrast, Alex Kotsky is meticulously neat when he works on his comic strip, "Apartment 3G." Stan Drake, who formerly drew "The Heart of Juliet Jones" and is now doing "Blondie," used photographs projected onto the surface of his drawing paper. Super draughtsmen? Definitely.

It has taken me a lifetime to answer this question: What is a drawing? Better still, what is *my* drawing? Of course, I can't be objective or offer a quick, simple answer. I know what emerges is a part of me. It is my own mark, my stamp.

I've been told, "Your drawings are better than your finished paintings." How true. I try to keep the original thought and the creative excitement all the way through to my finished artwork. But sometimes the clear, spontaneous concept becomes muddled and overworked. The real draughtsmanship is accomplished with the first marks of a pencil, pen, or brush.

Many of us make renderings, renderings that are detailed delineations, shaped, shaded, and detailed to a fare-thee-well. I have rendered many turkeys! But once in a while, I make a drawing!

This is indeed another "Draw 50," with emphasis on basic construction of the human figure. It is my wish that it may free you to be you and to draw, not render.

CREIG FLESSEL

To the Reader

When you start working I suggest you use clean white bond paper or drawing paper and a pencil with moderately soft lead (HB or No. 2). Keep a kneaded eraser (available at art supply stores) handy. Choose the subject you want to draw and then, very lightly and very carefully, sketch out the first step. Also very lightly and carefully, add the second step. As you go along, study not only the lines but the spaces between the lines. Size your first steps to fill your drawing paper agreeably, not too large, not too small. Remember, the first steps must be constructed with the greatest care. A mistake here could ruin the whole thing.

As you work, it's a good idea, from time to time, to hold a mirror to your sketch. The image in the mirror frequently shows distortion you might not have recognized otherwise.

You will notice new step additions are printed darker. This is so they can be clearly seen. But keep your construction steps always very light. Here's where the kneaded eraser can be useful. You can lighten a pencil stroke that is too dark by pressing on it with the eraser.

When you've completed all the light steps and are sure you have everything the way you want it, finish your drawing with firm, strong penciling. If you like, you can go over this with India ink (applied with a fine brush or pen), or a permanent fine-tipped ballpoint or felt-tipped marker. When your work is thoroughly dry, you can then use the kneaded eraser to clean out all the underlying pencil marks.

Remember, if your first attempts at drawing do not turn out the way you'd like, it's important to *keep trying*. Your efforts *will* eventually pay off, and you'll be pleased and surprised at what you can accomplish. I sincerely hope, as you follow our techniques, you'll improve your own skills. Mimicking the drawings in this book can open the door to your own creativity. Now have a great time drawing us, drawing people!

16. j

DRAW 50 PEOPLE

Cleonatra and the Asn (Fountian Cohra)

Ancient Egyptian Mathematician

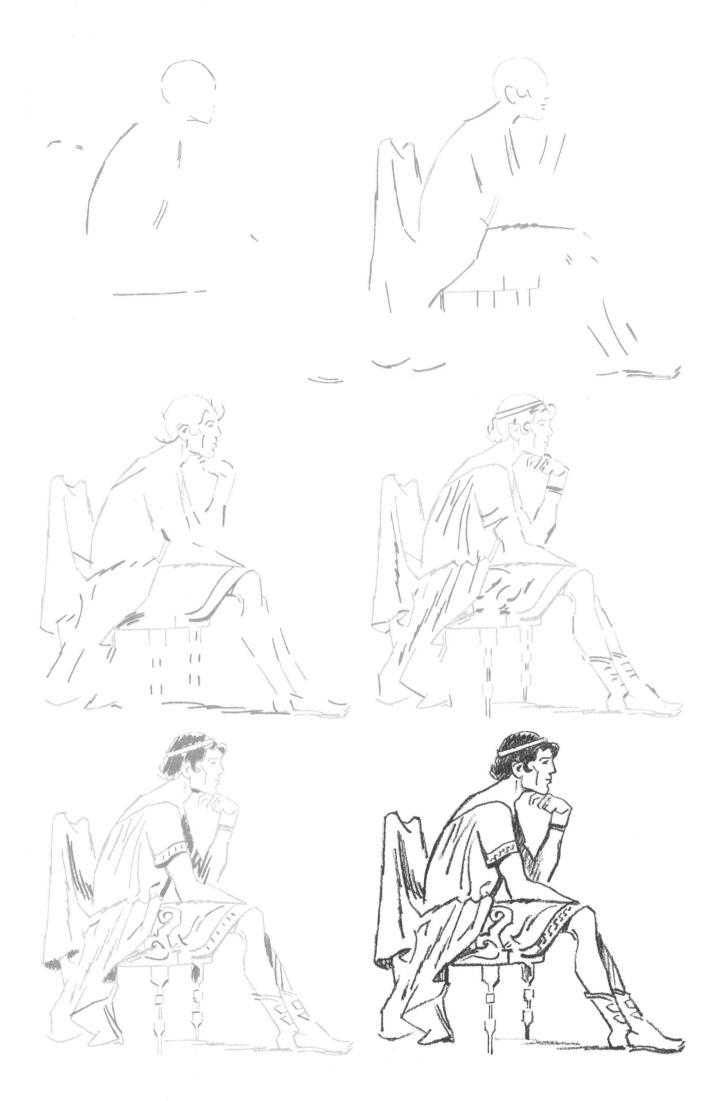

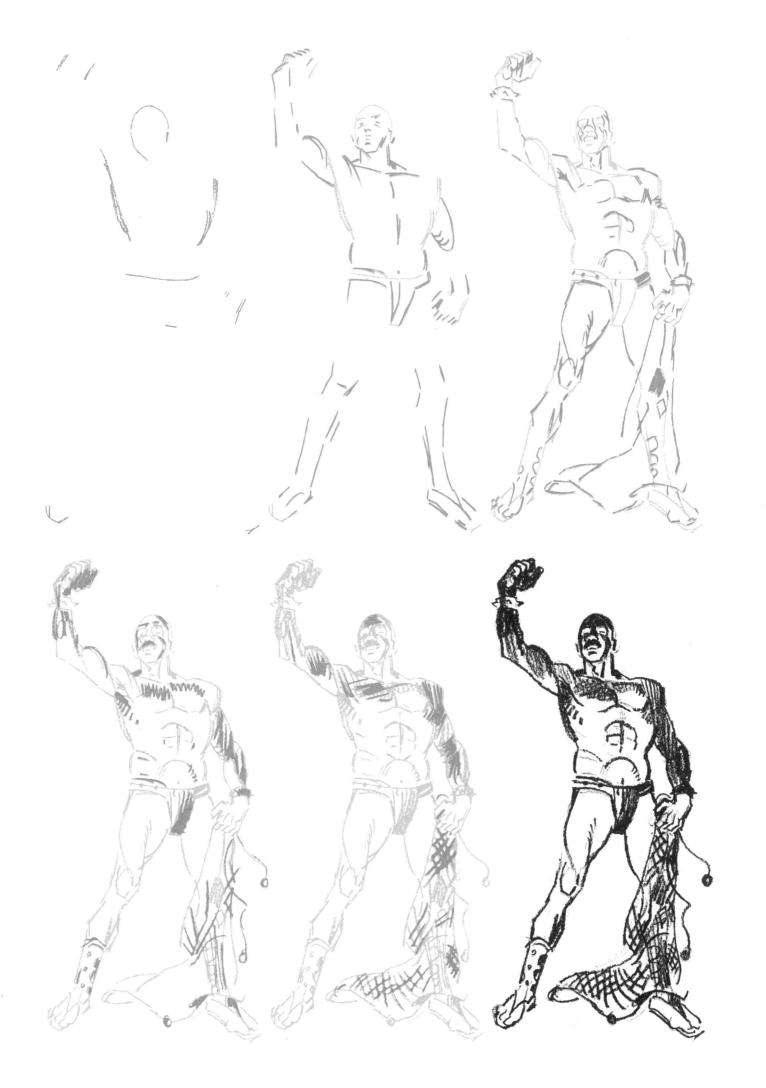

African Gladiator

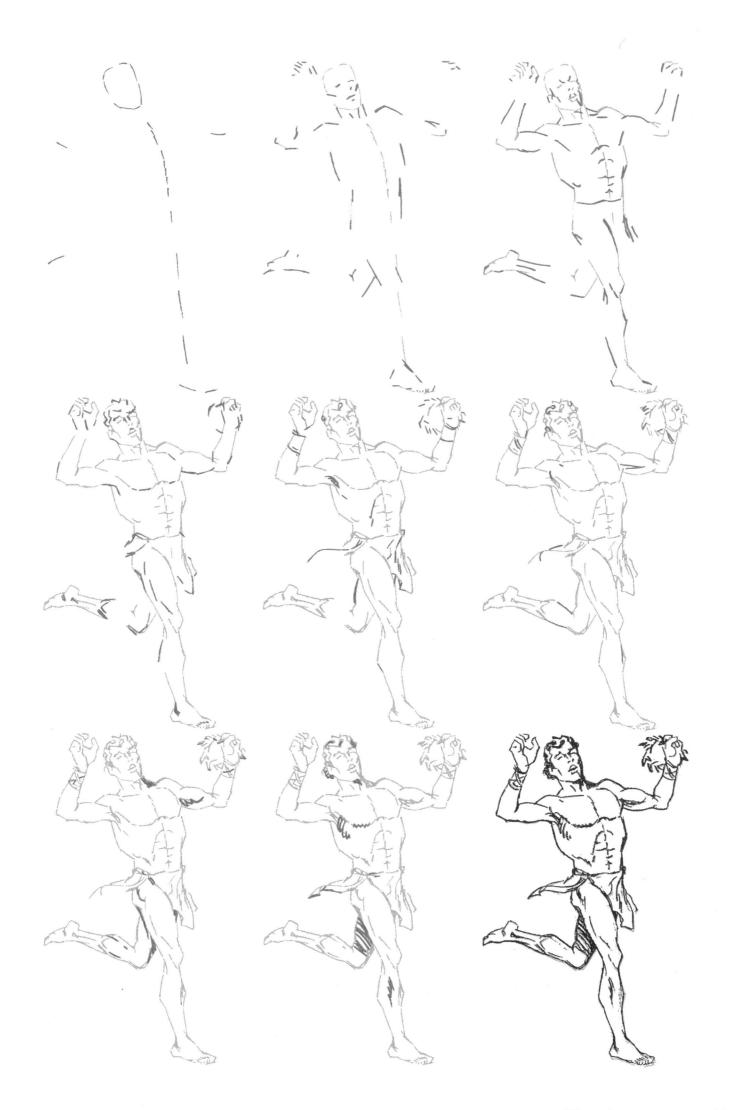

Victorious Roman Athlete

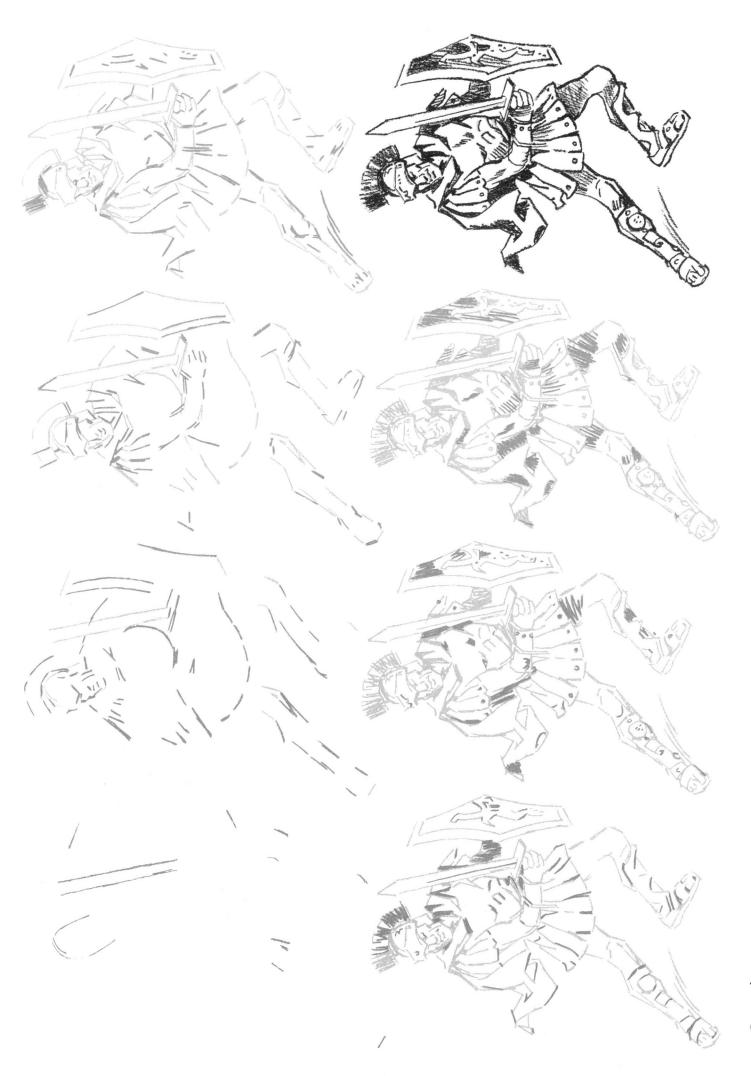

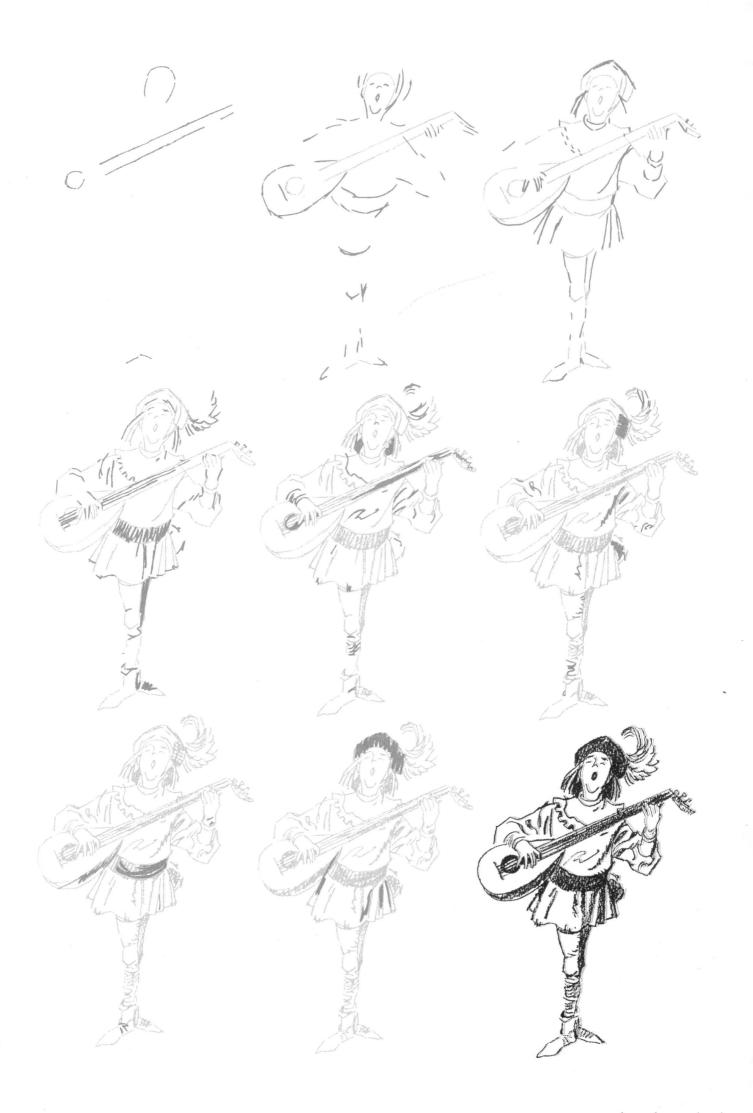

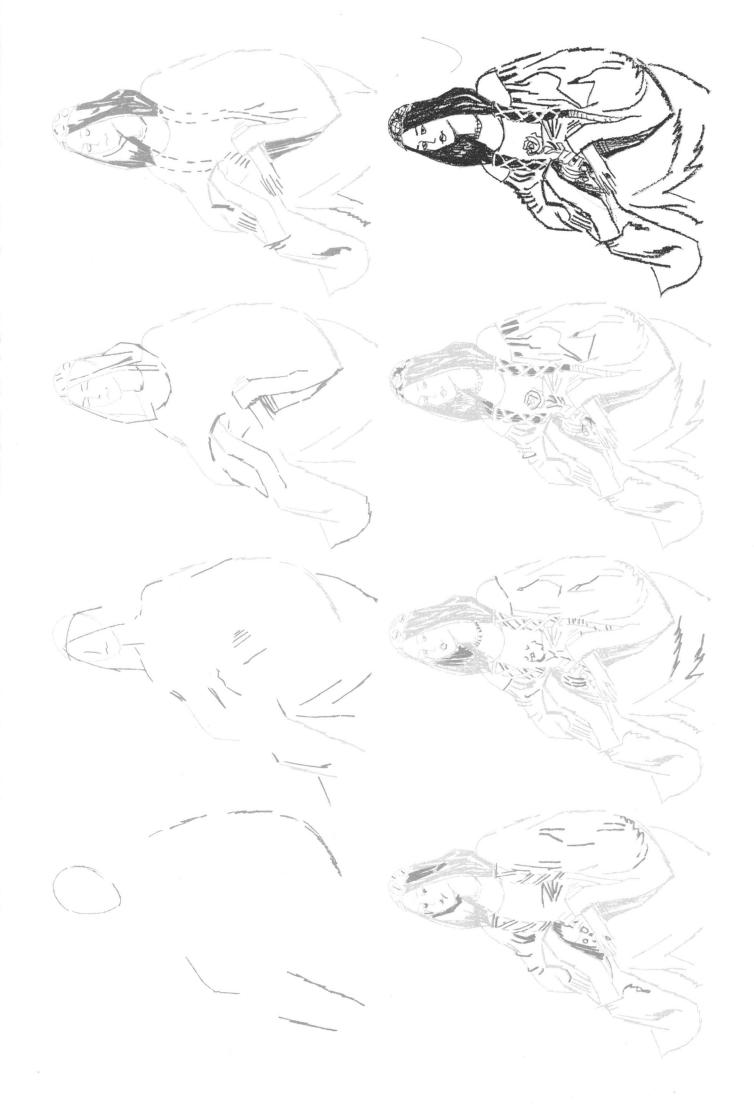

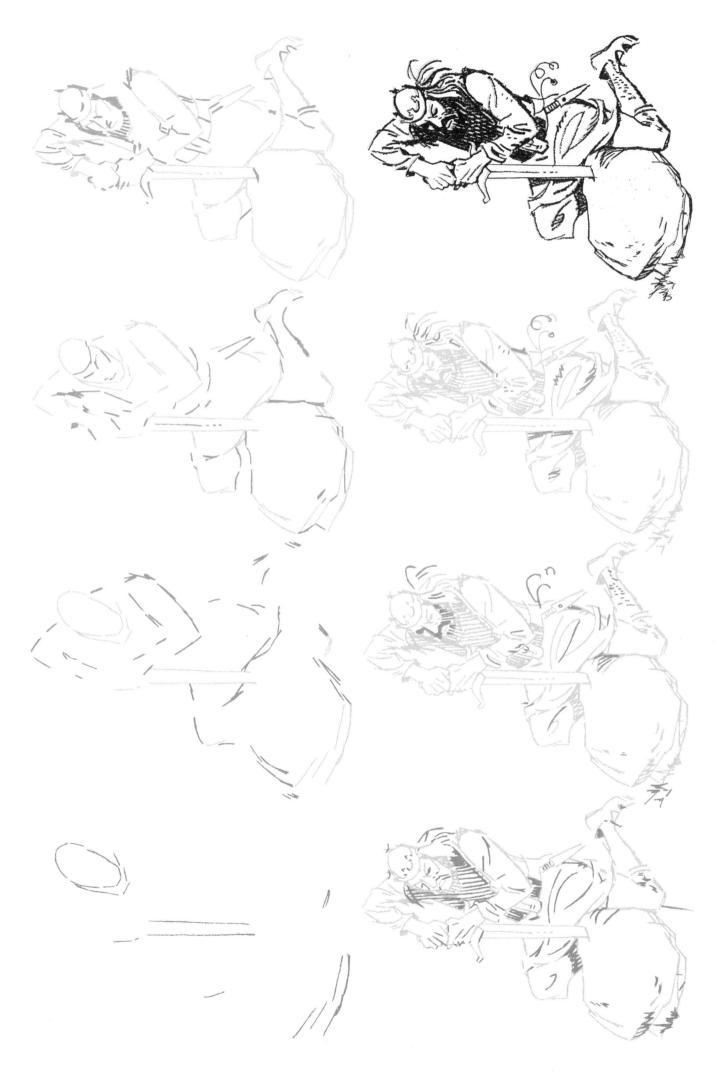

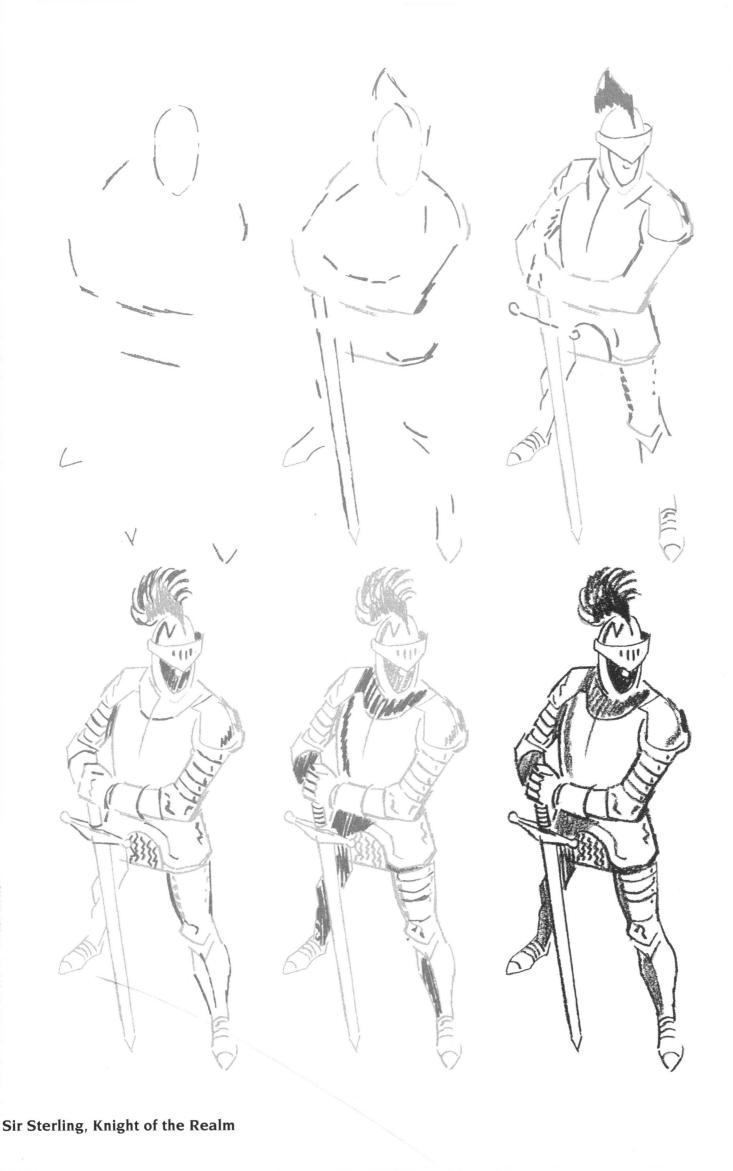

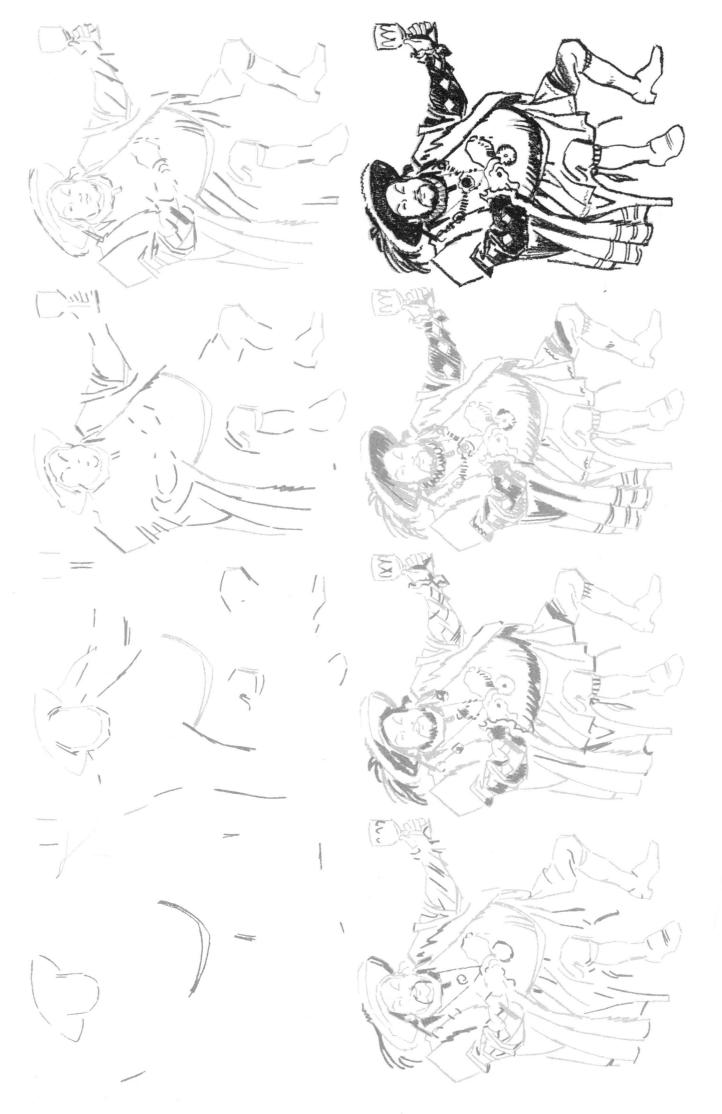

King Henry VIII

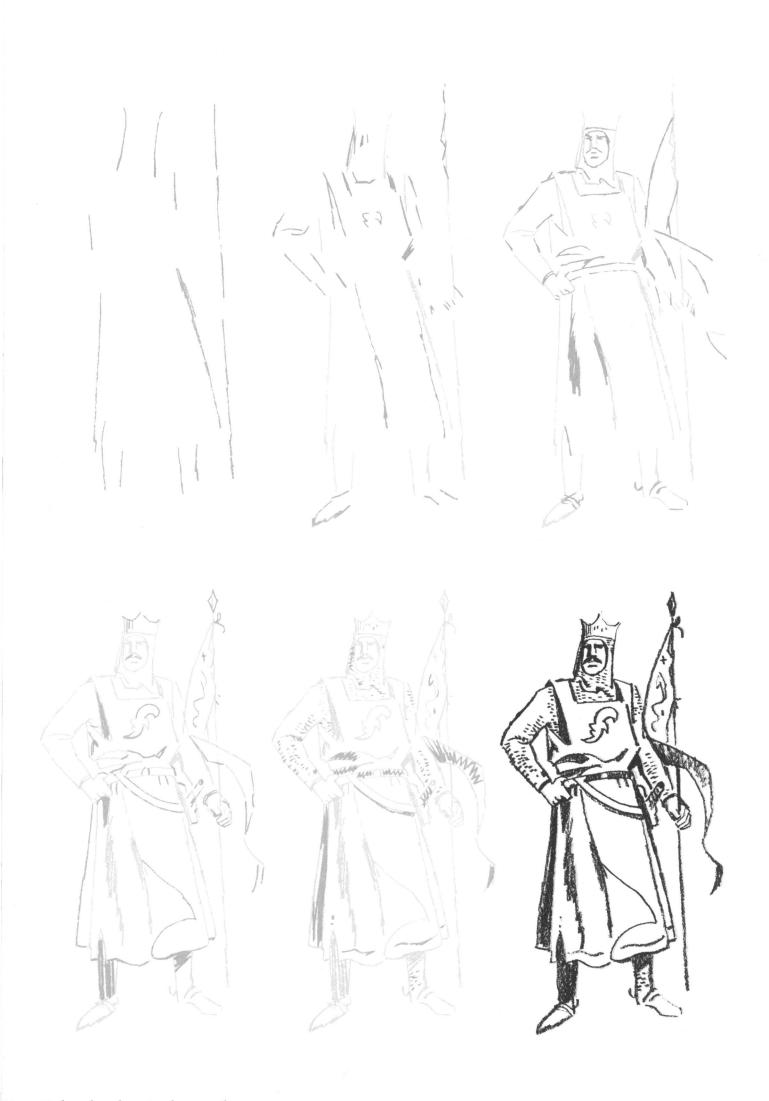

King Richard I, the Lionhearted

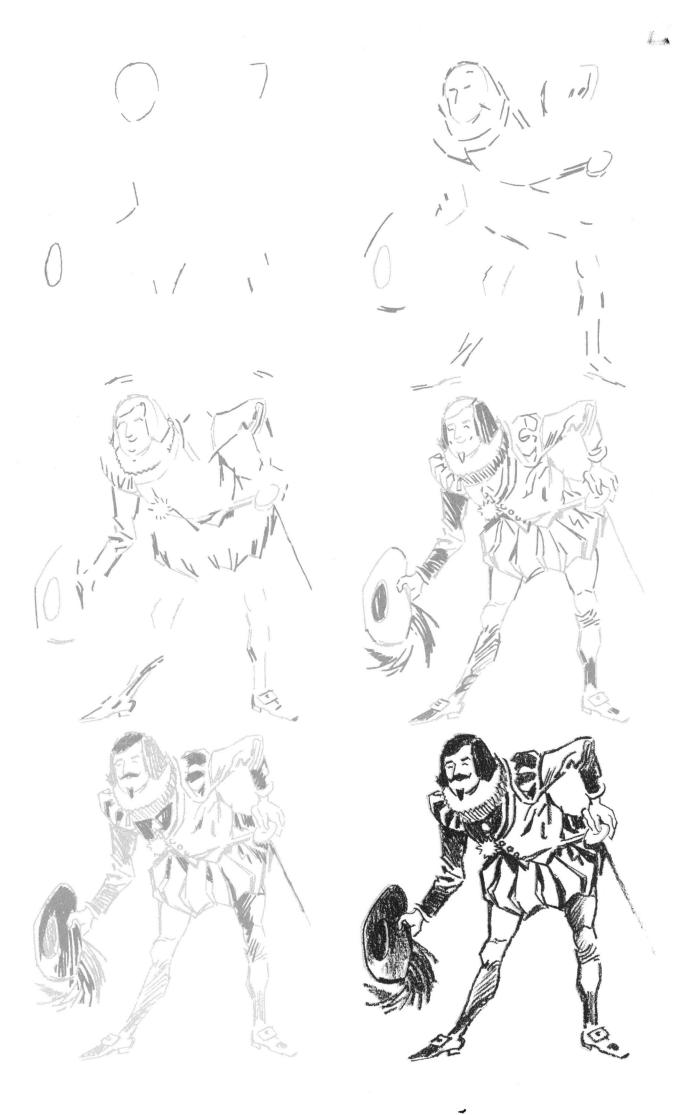

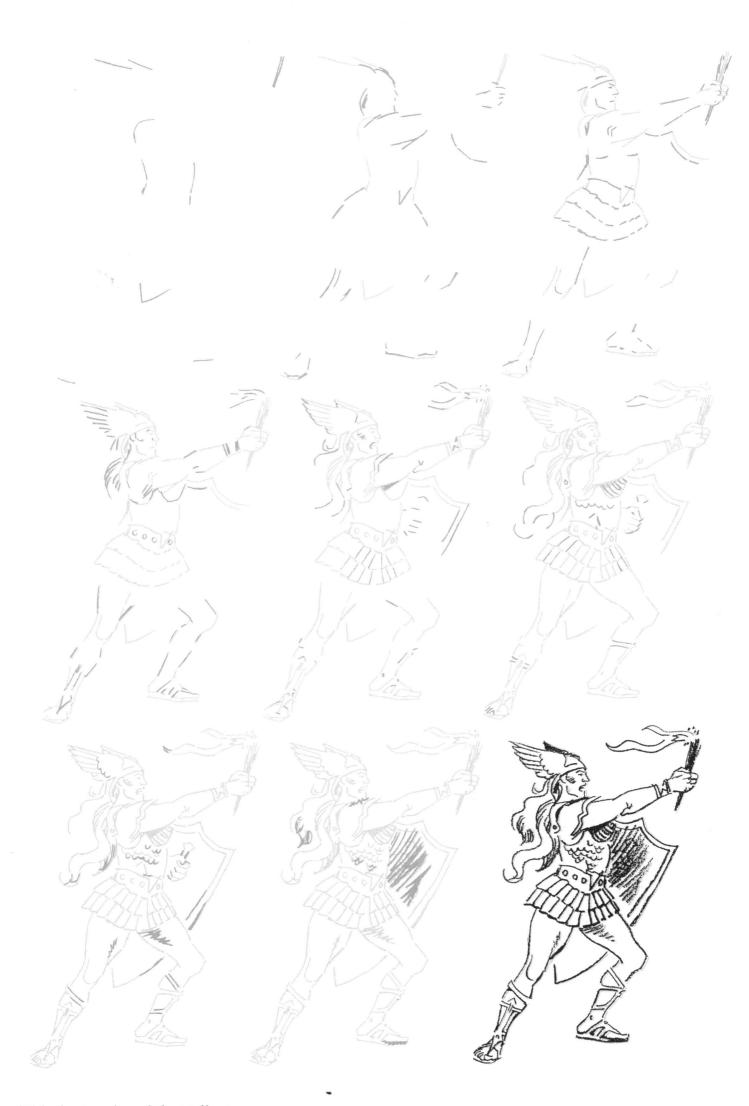

Brynhild, the Leader of the Valkyries

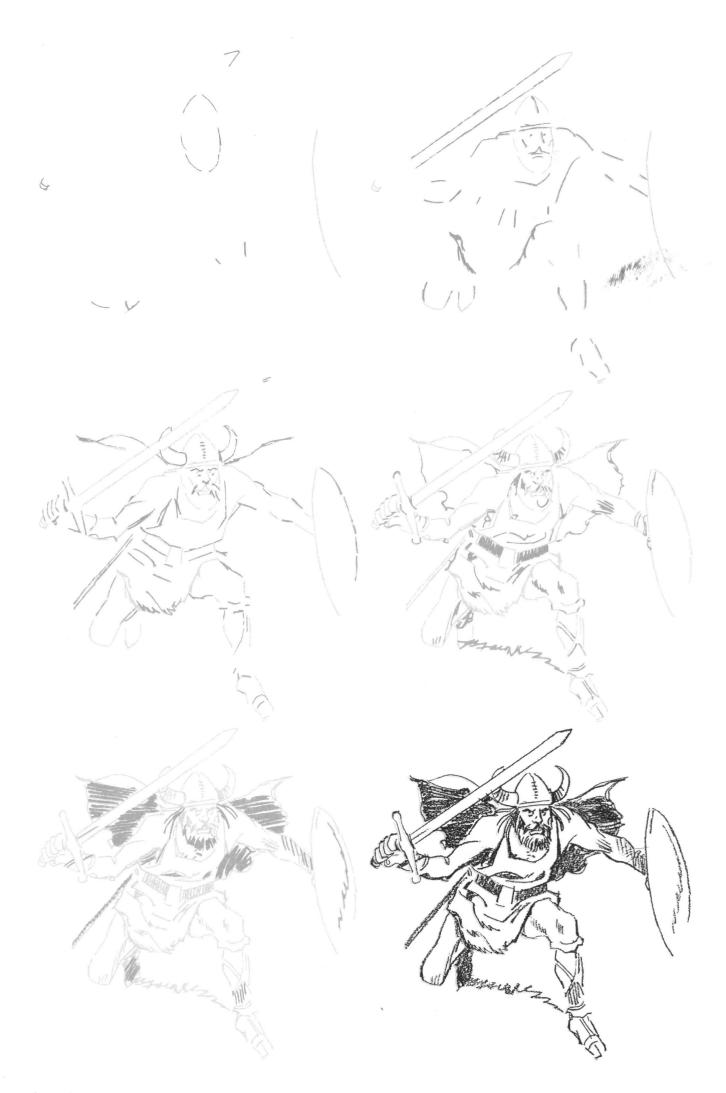

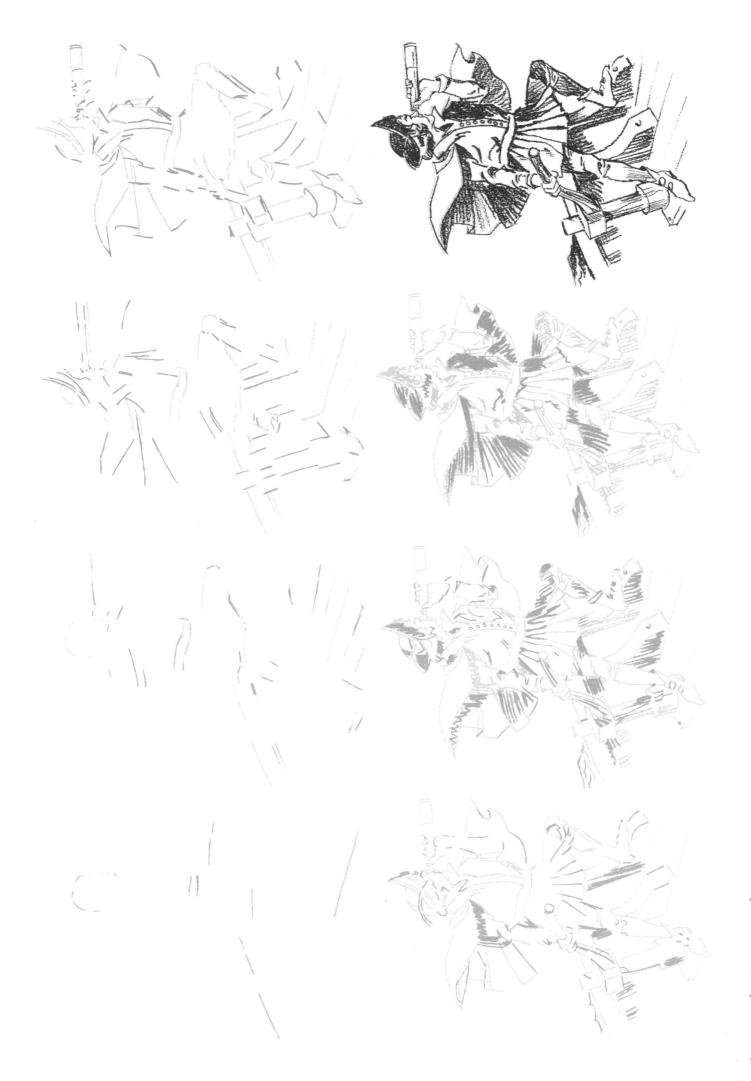

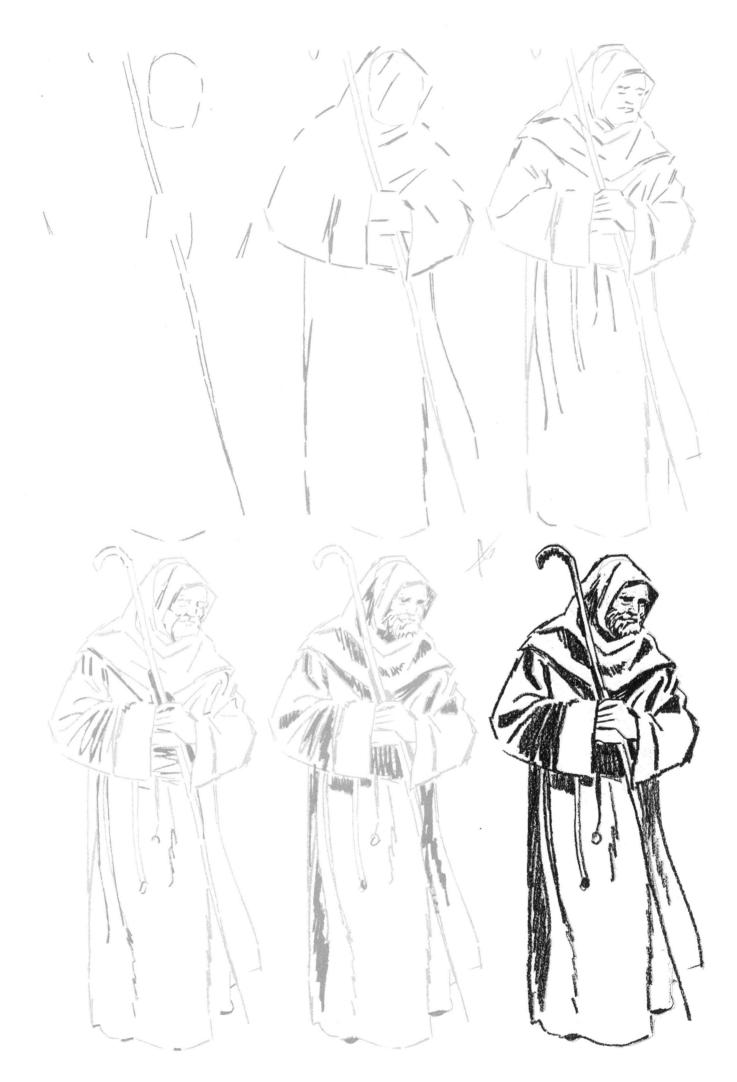

Monk, Fifteenth Century

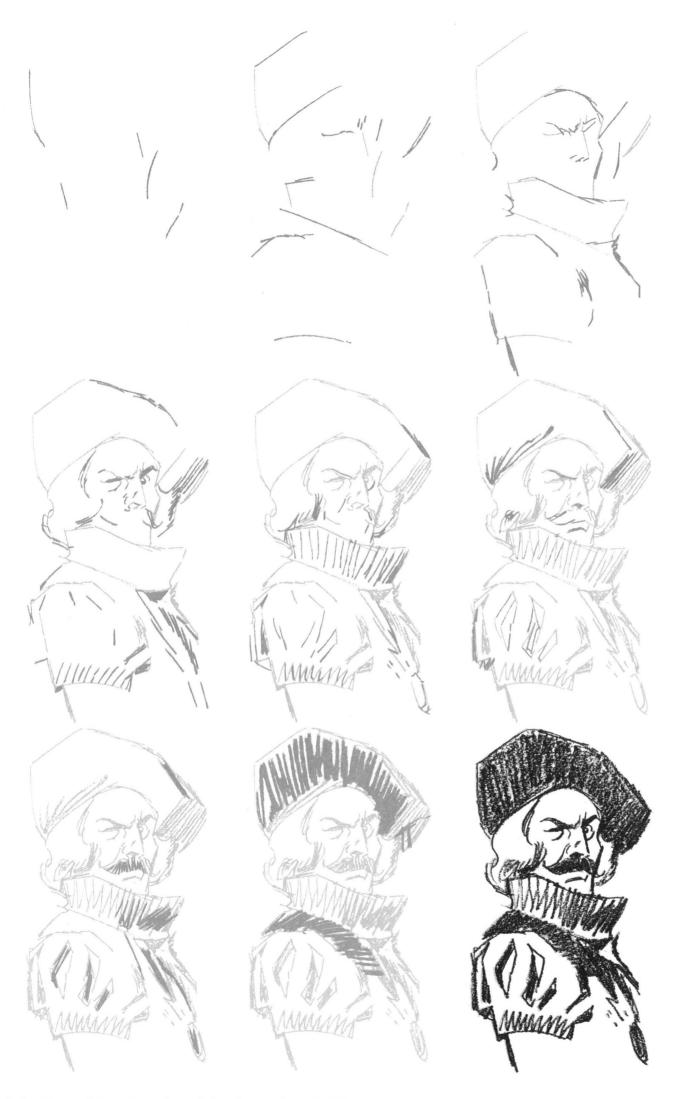

amuel de Champlain, Founder of Quebec, circa 1608

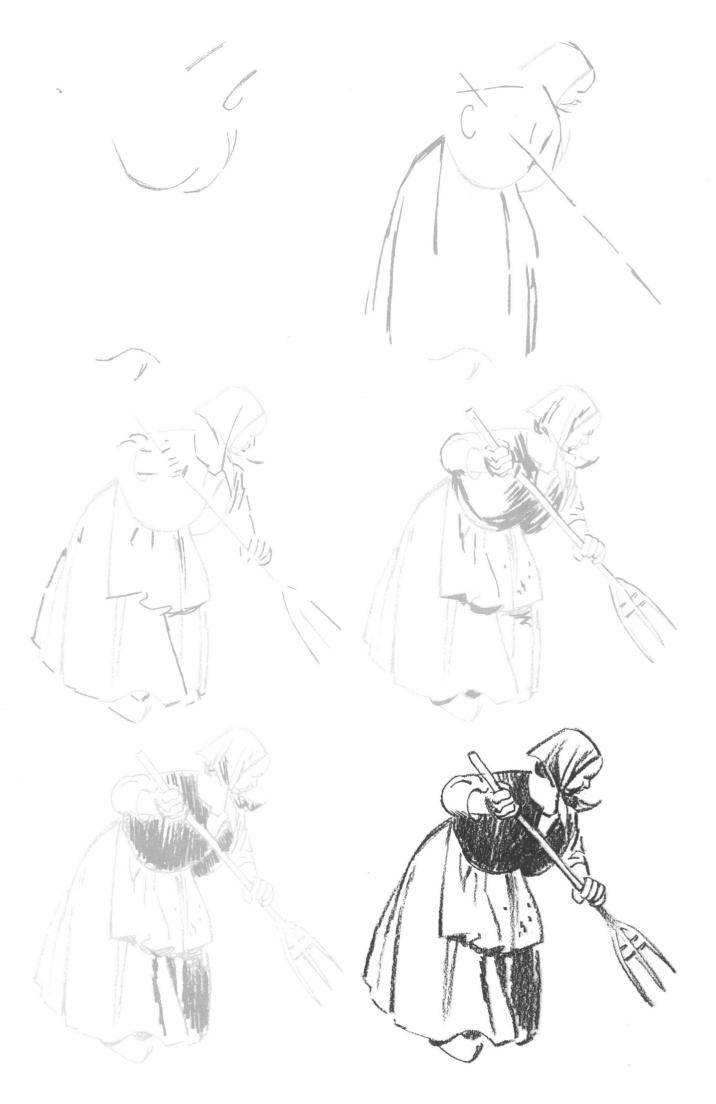

Flemish Peasant, Seventeenth Century

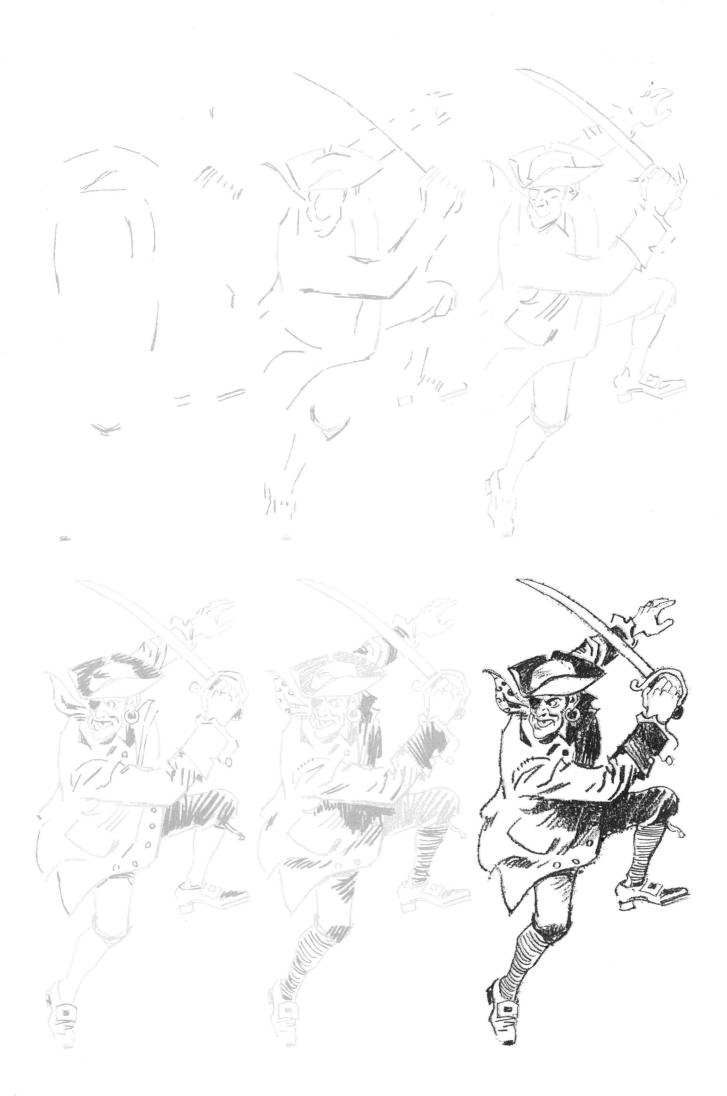

Putrid Pierre, the Pirate

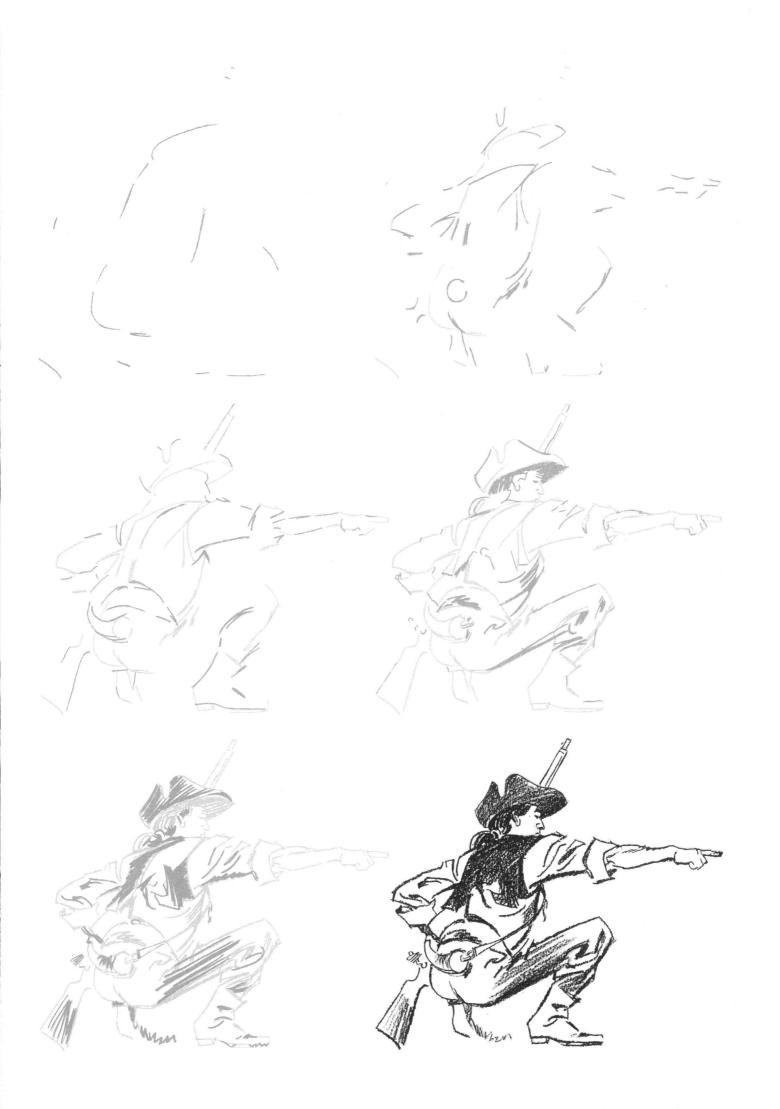

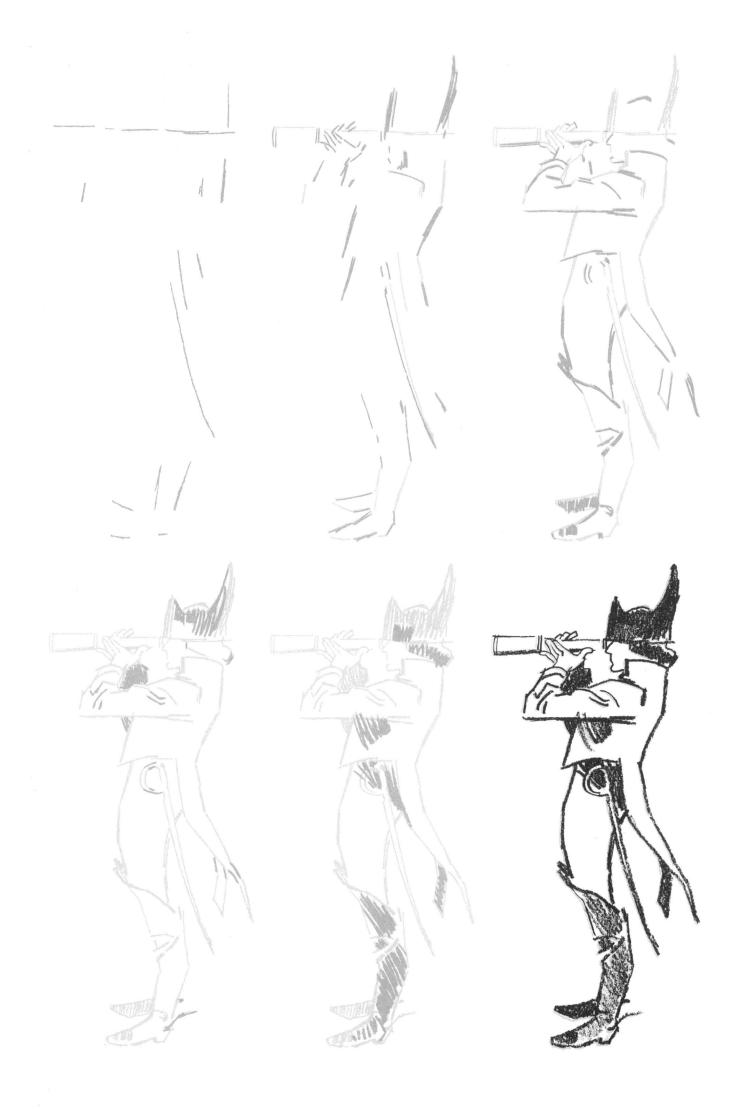

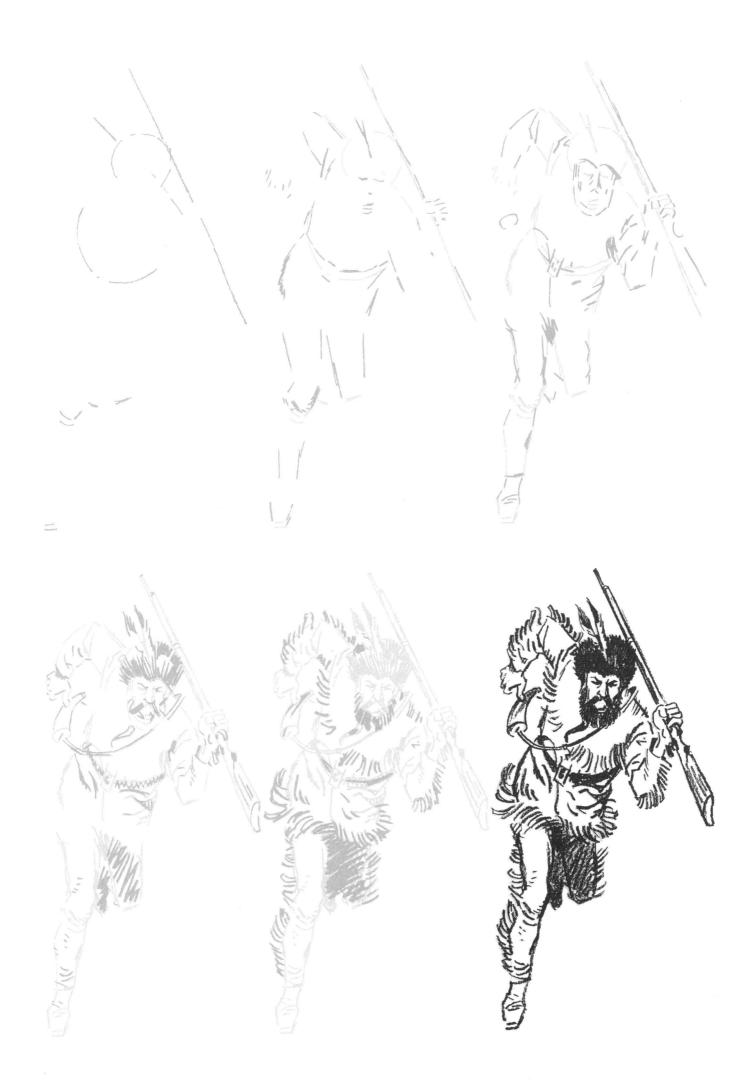

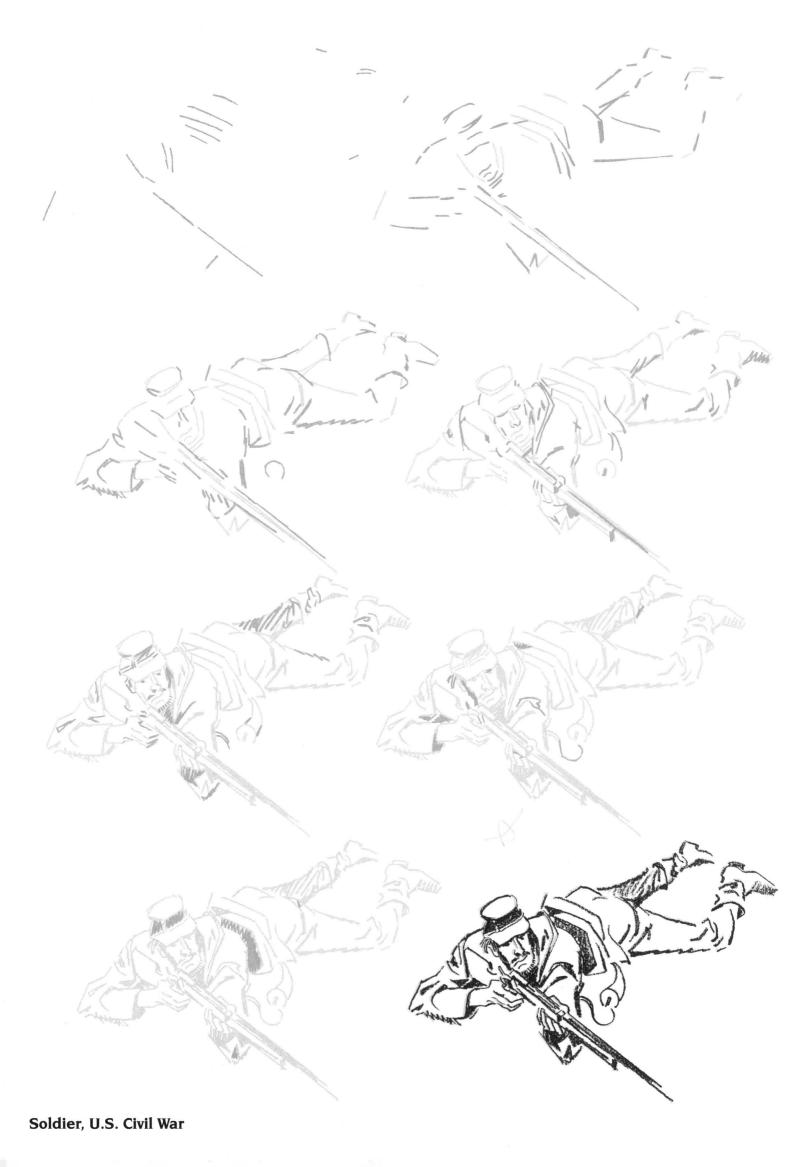

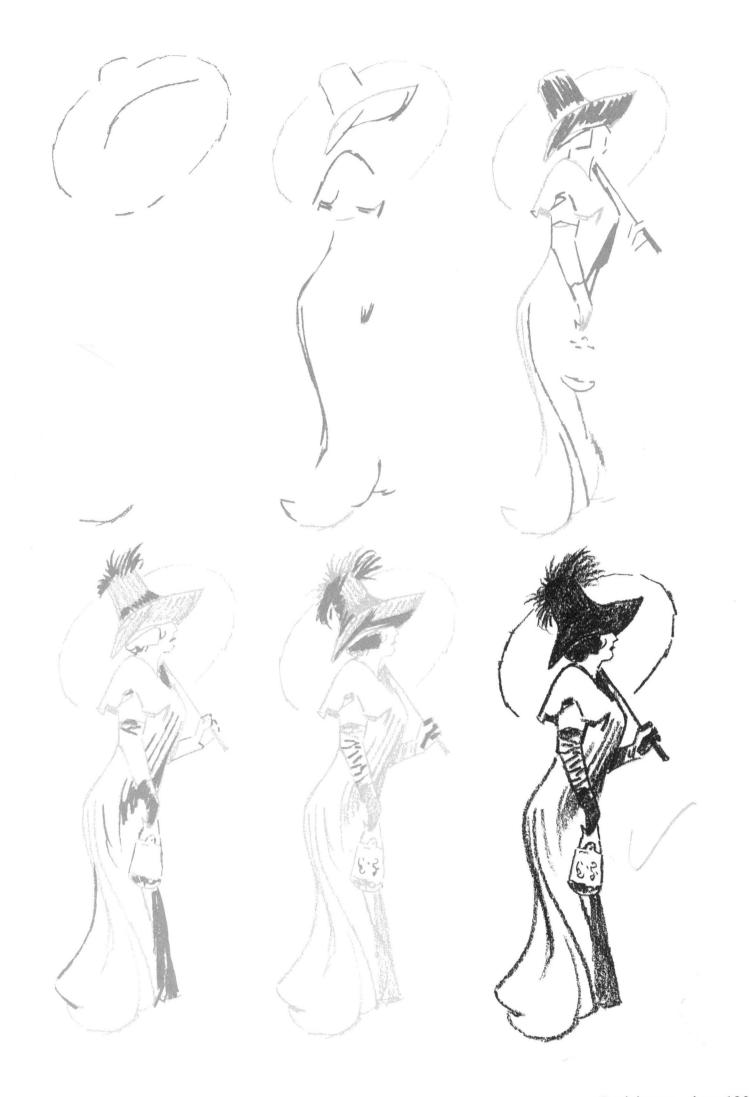

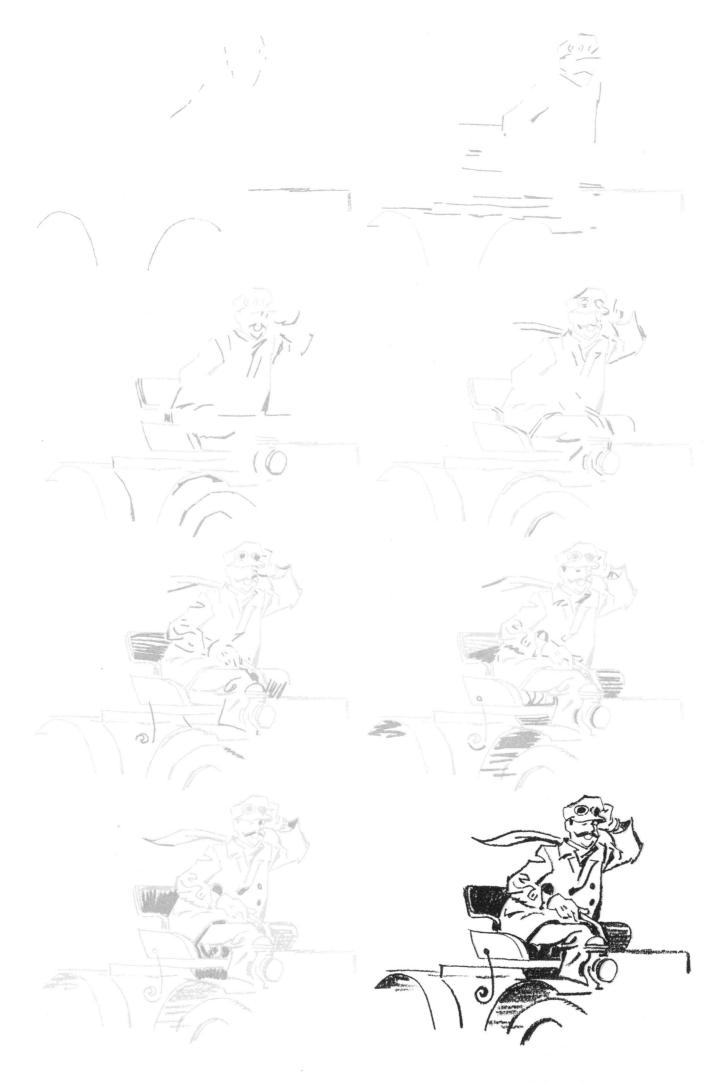

Driving a "Horseless Buggy," circa 190

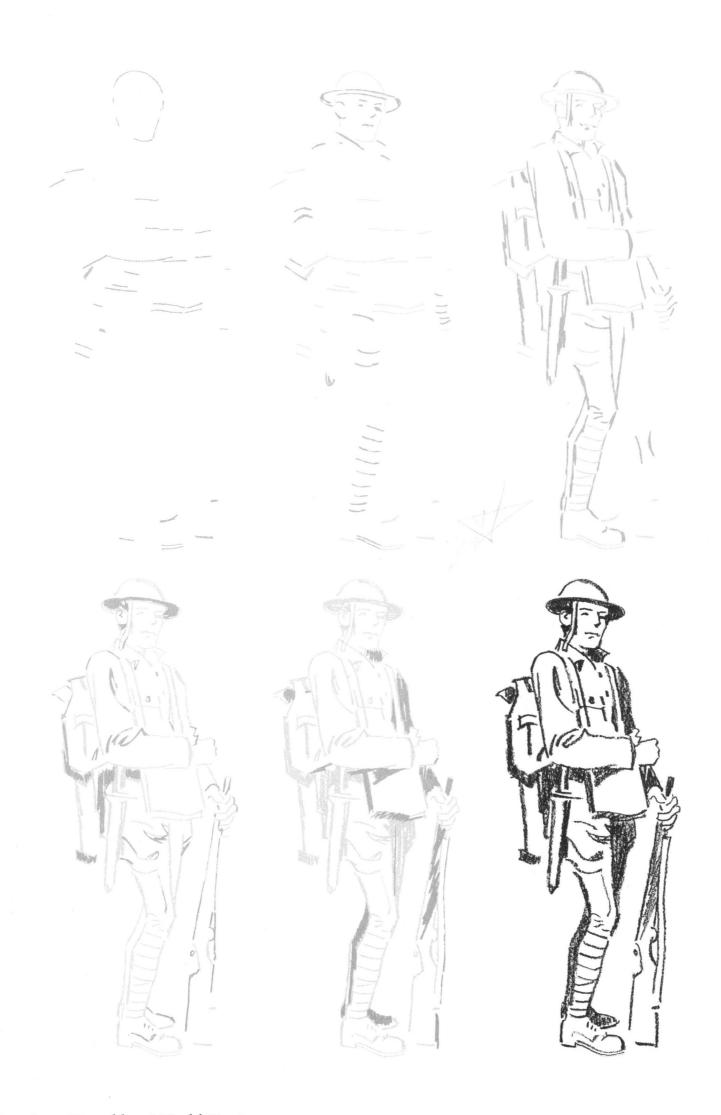

toward the Pauls 1020s

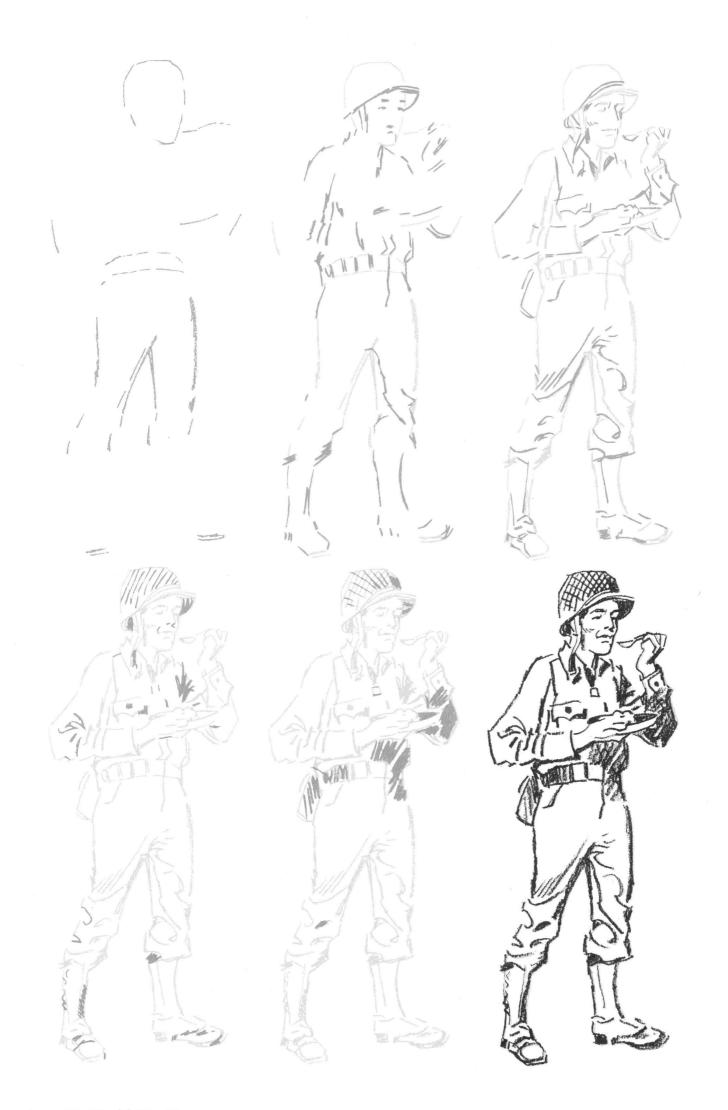

American GI, World War II

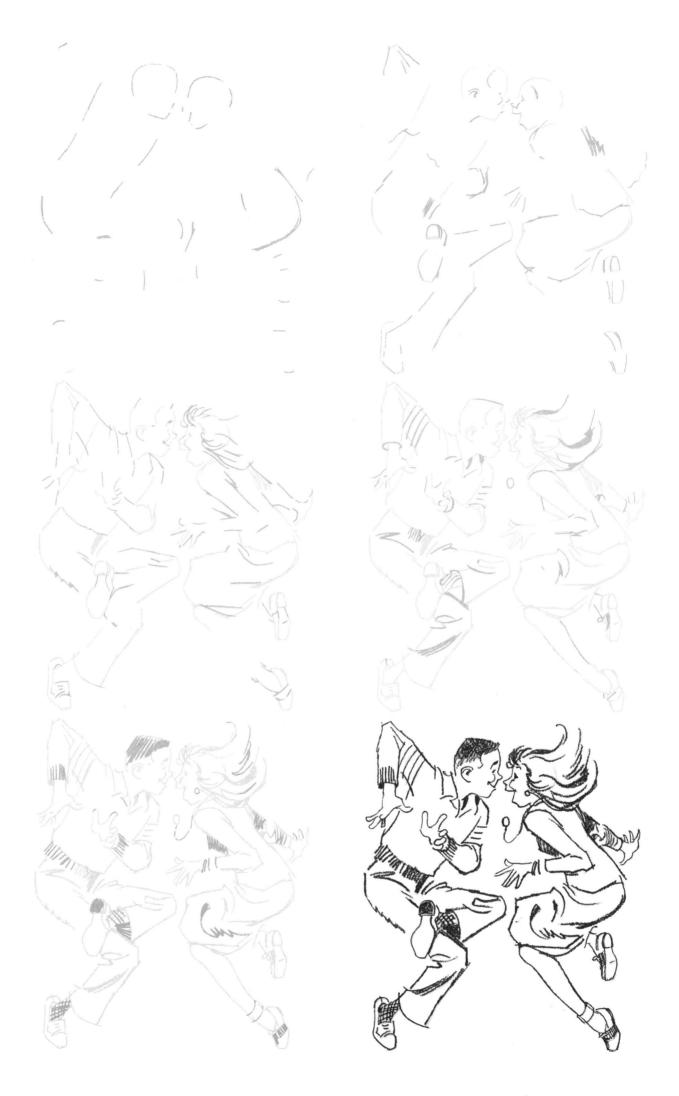

Jitterbugging in the Late 1940s

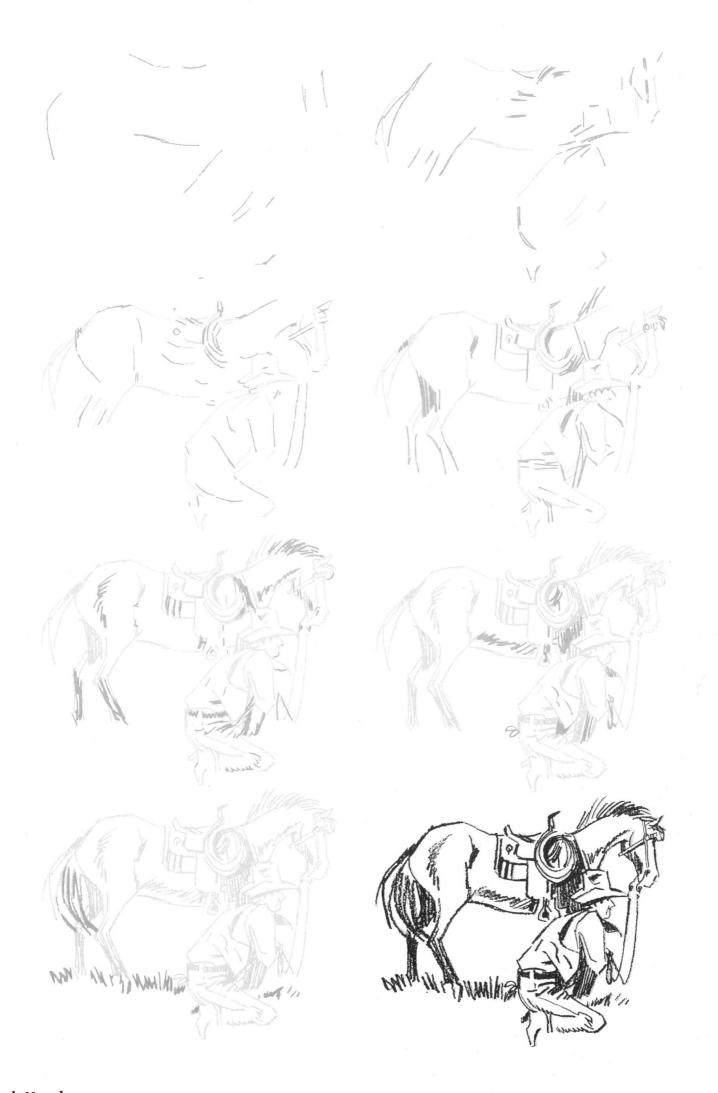

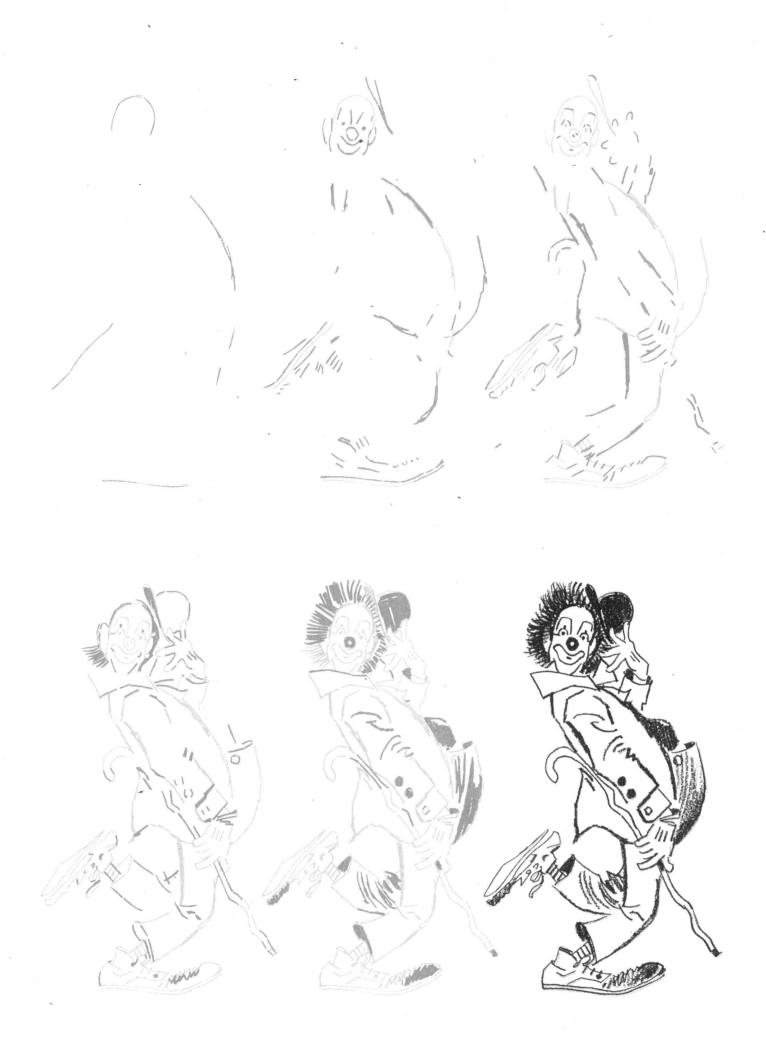

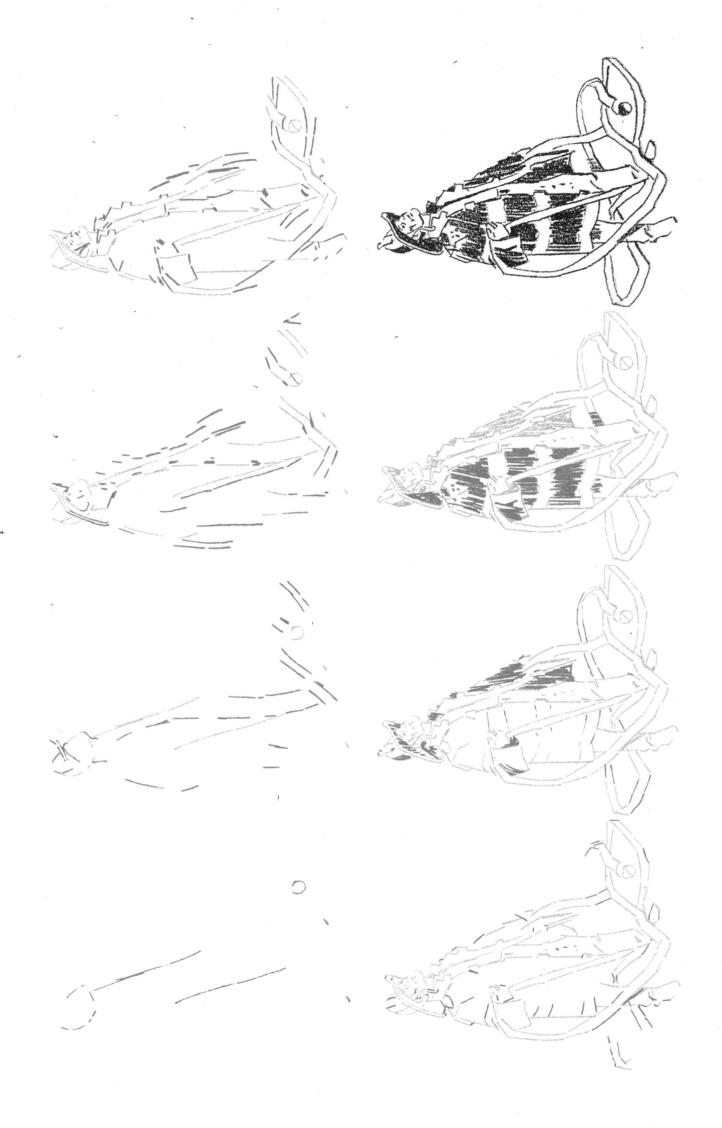

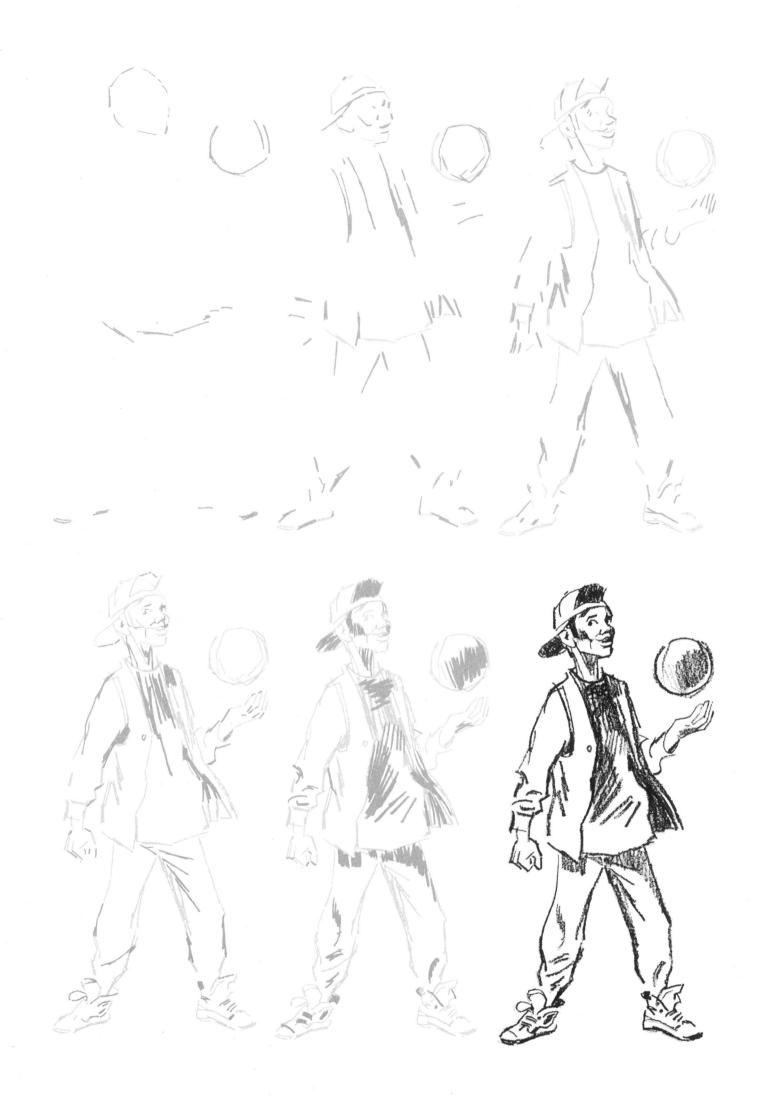

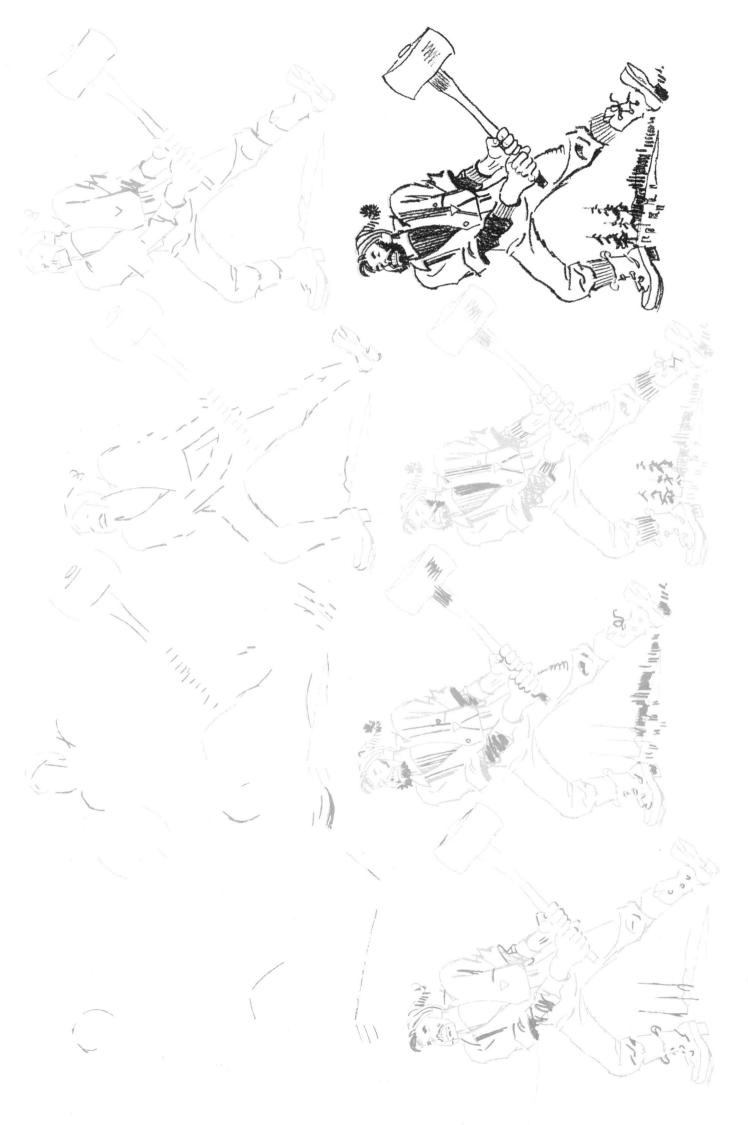

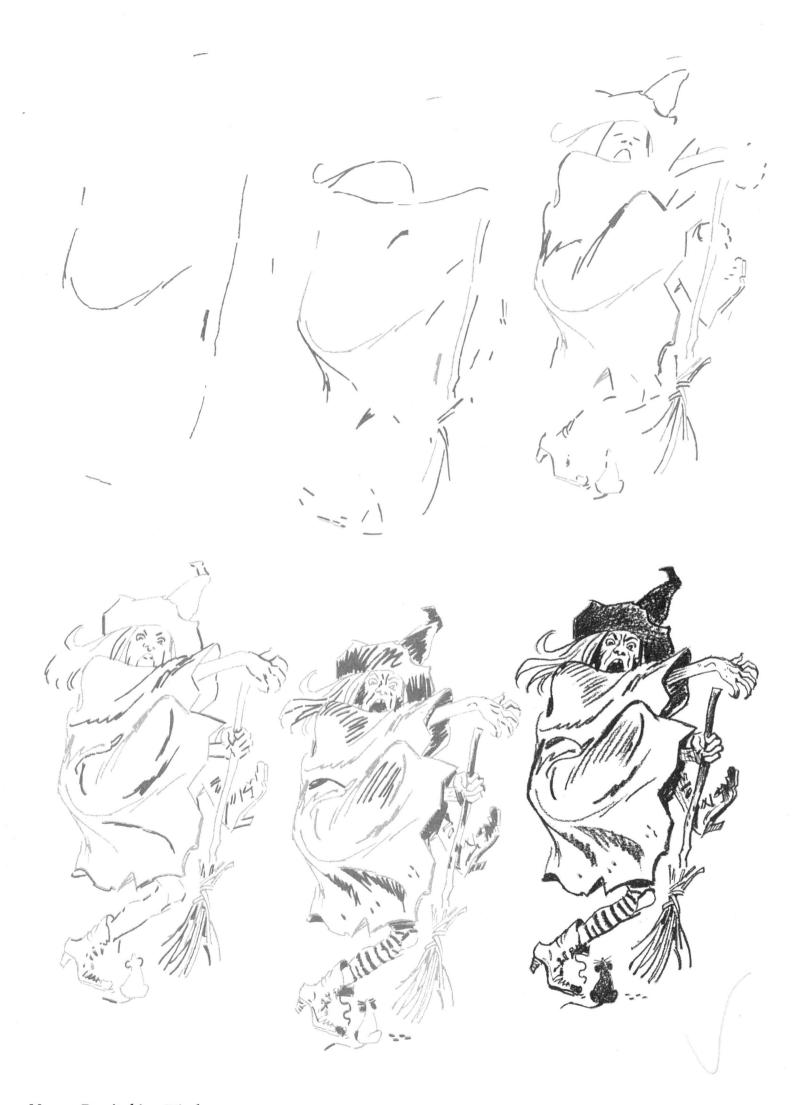

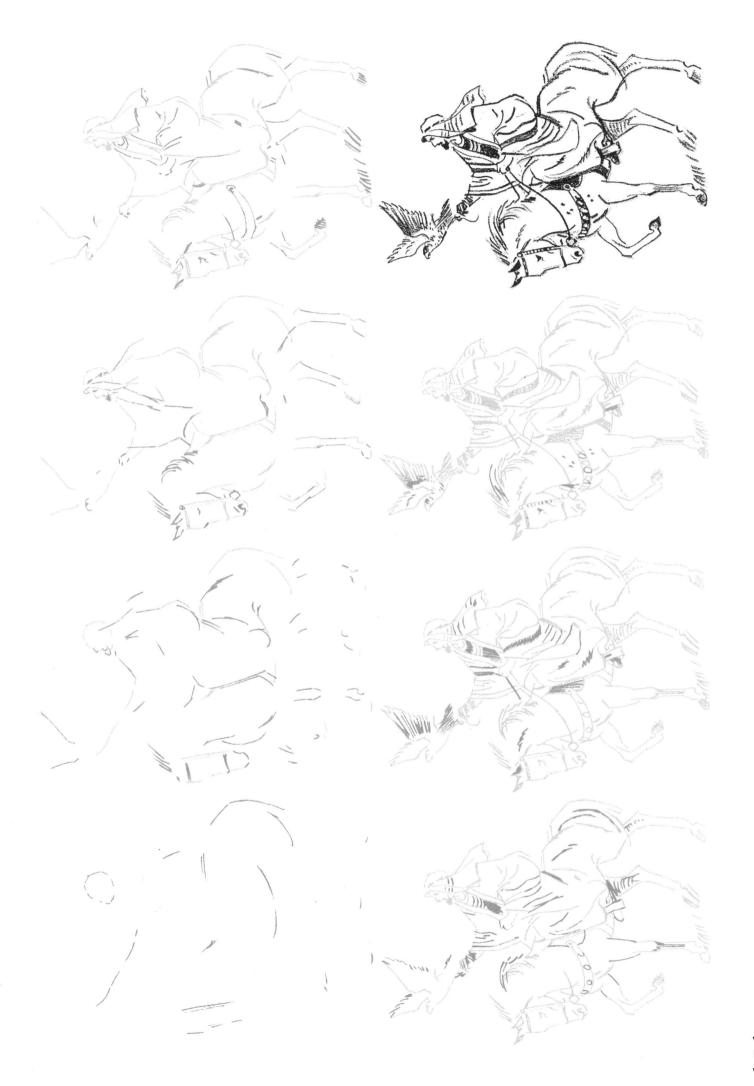

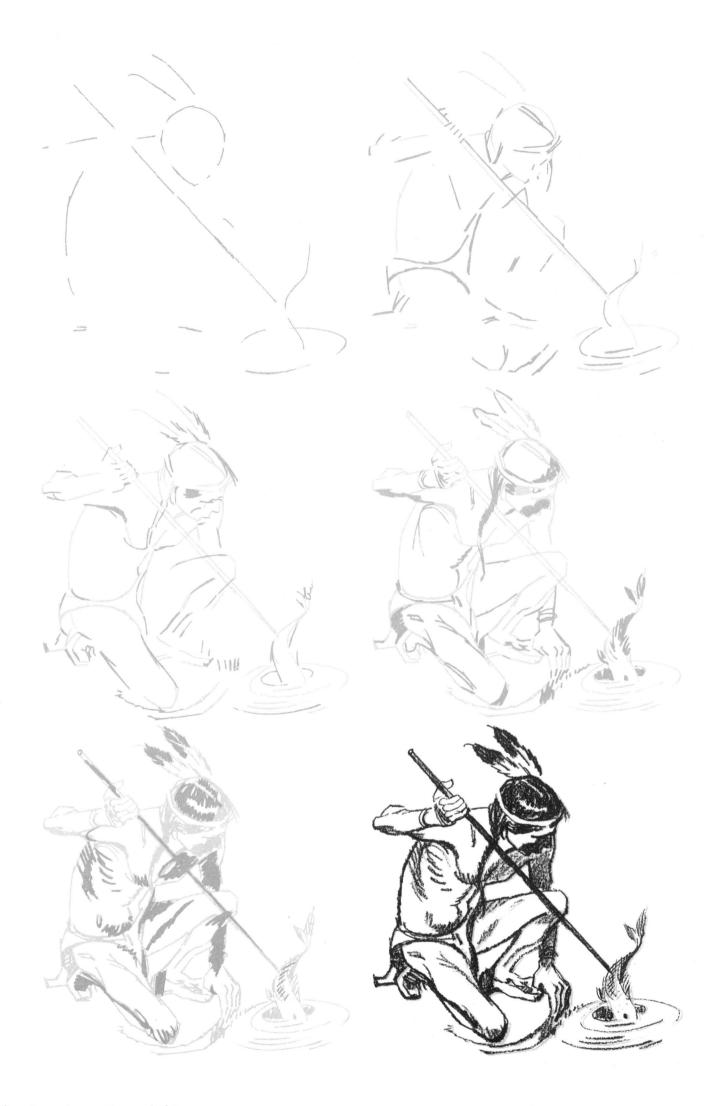

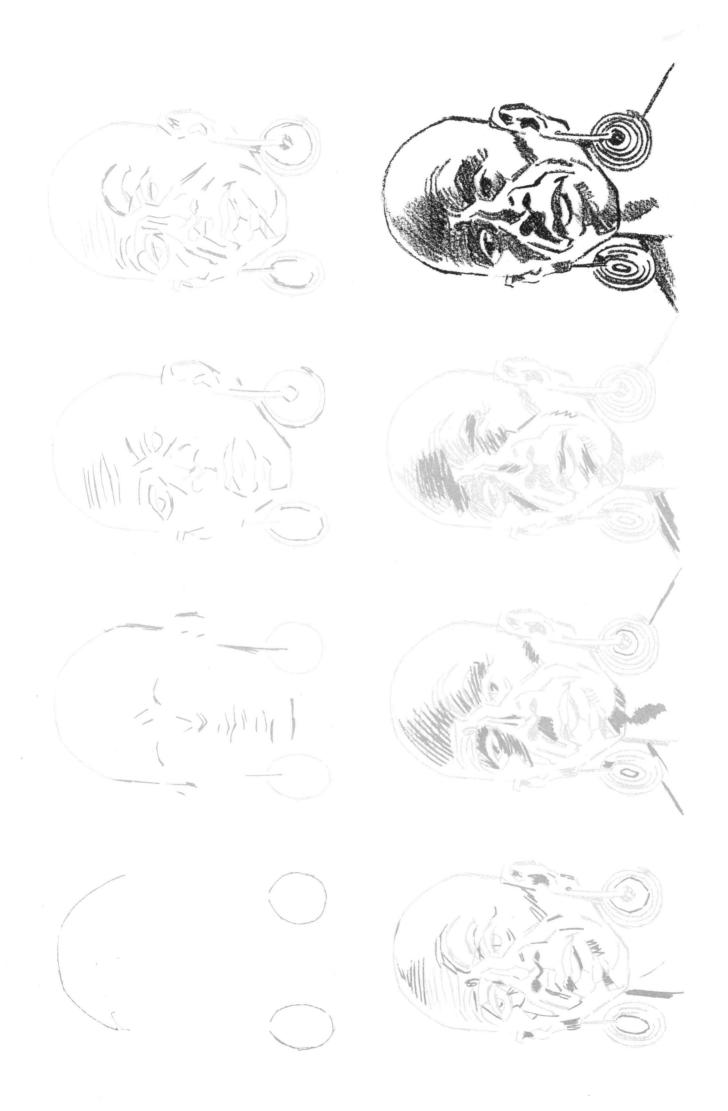

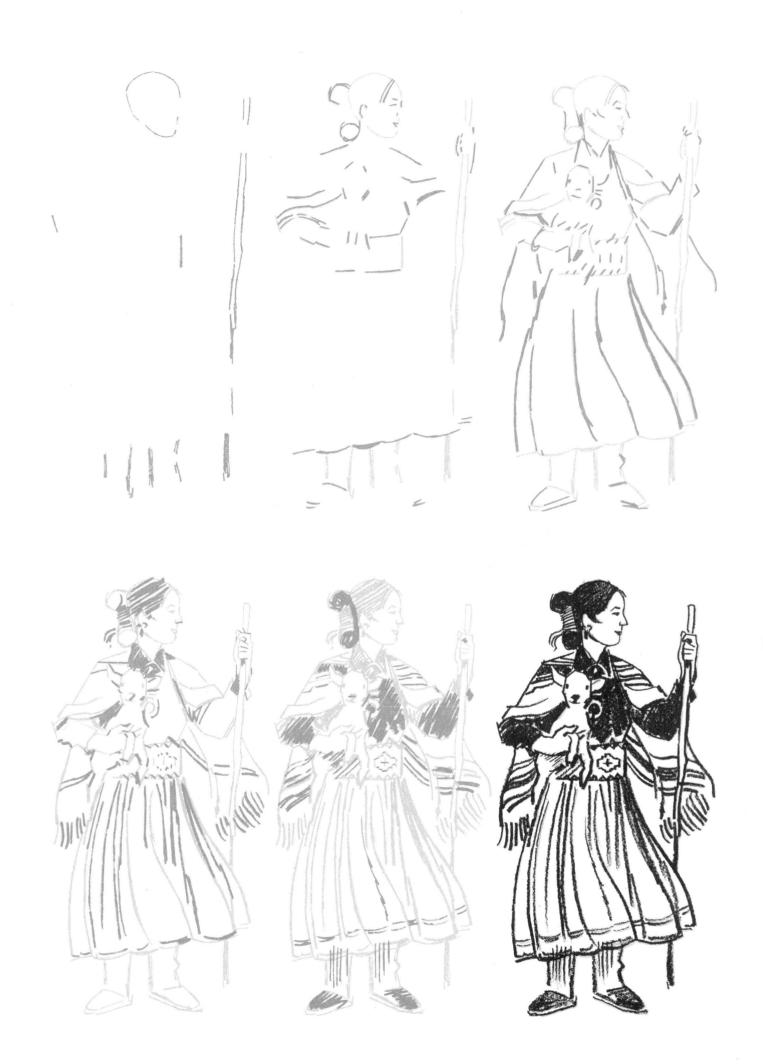

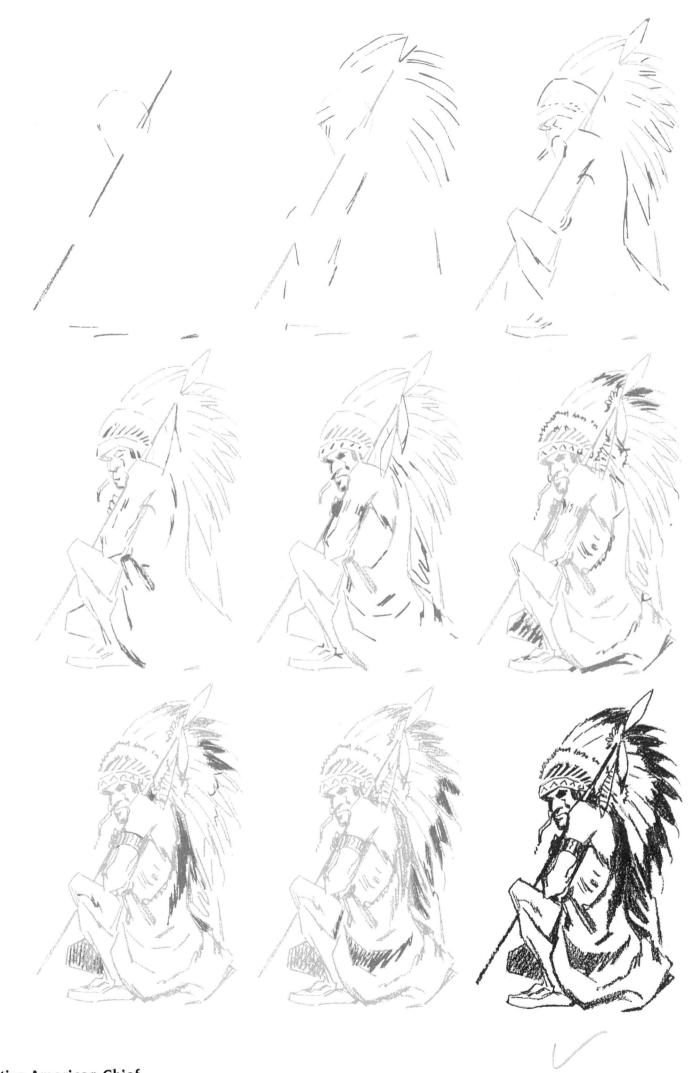

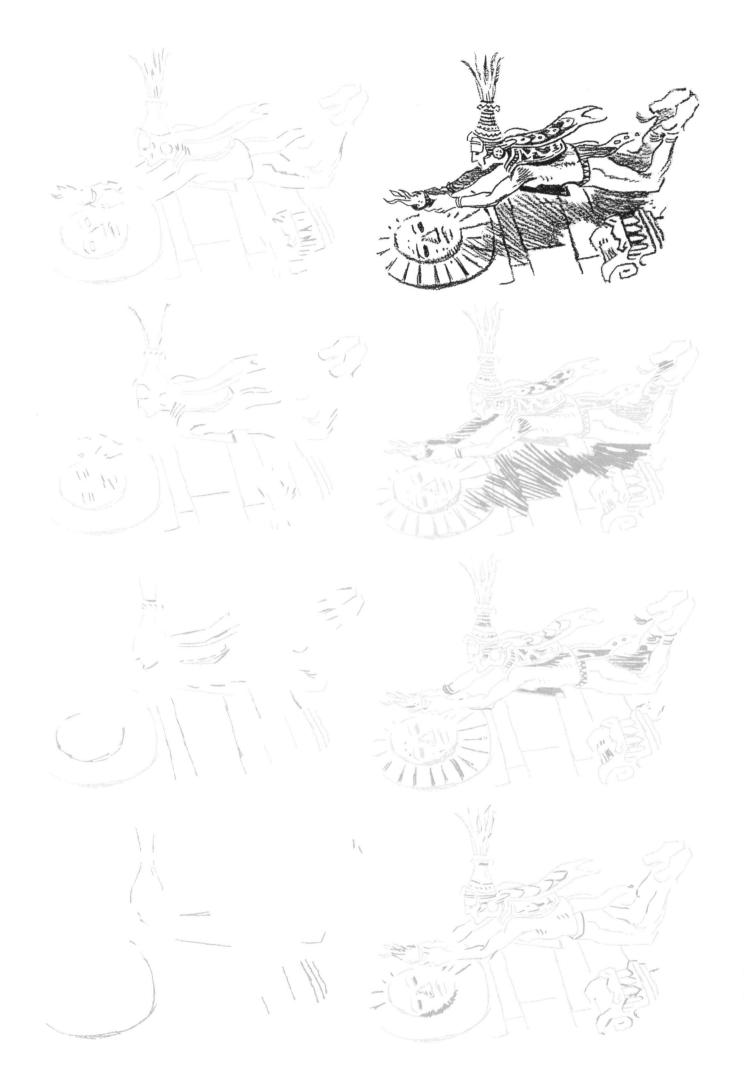

Aztec (Pre-Columbian Mexican) at the Altar of Huitzilopochtli

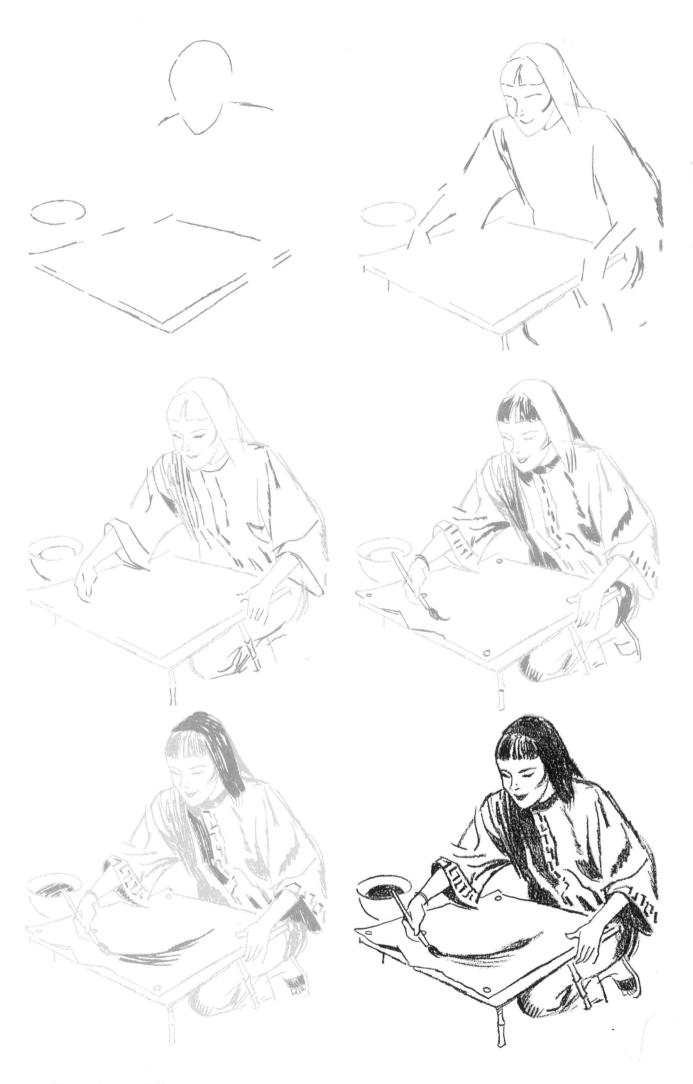

Painting Calligraphy on Silk

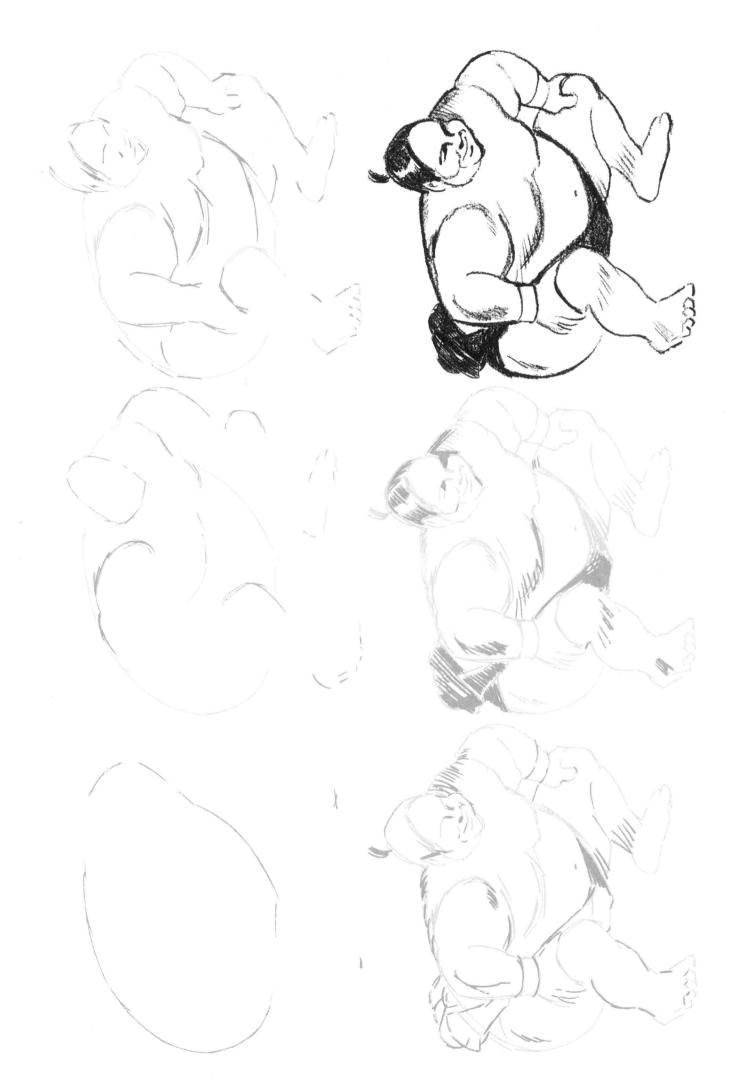

Tsuyoi Yama, Sumo Wrestler

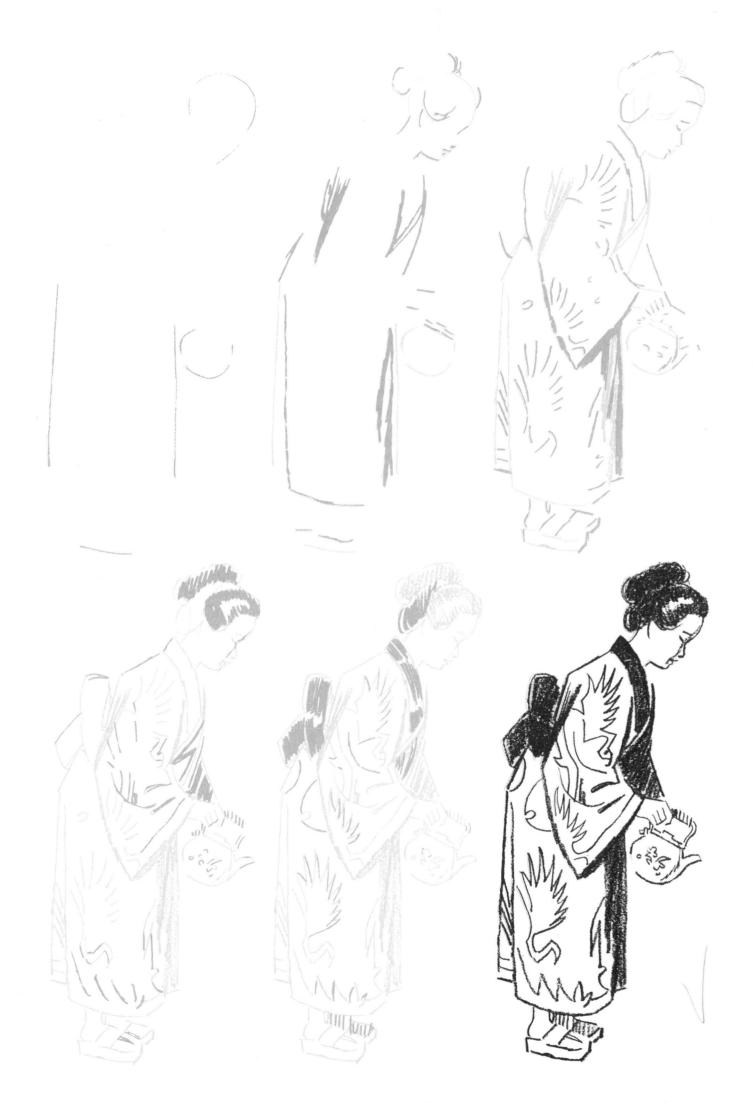

Fujin with Chazutsu (Japanese Woman with Tea Canister

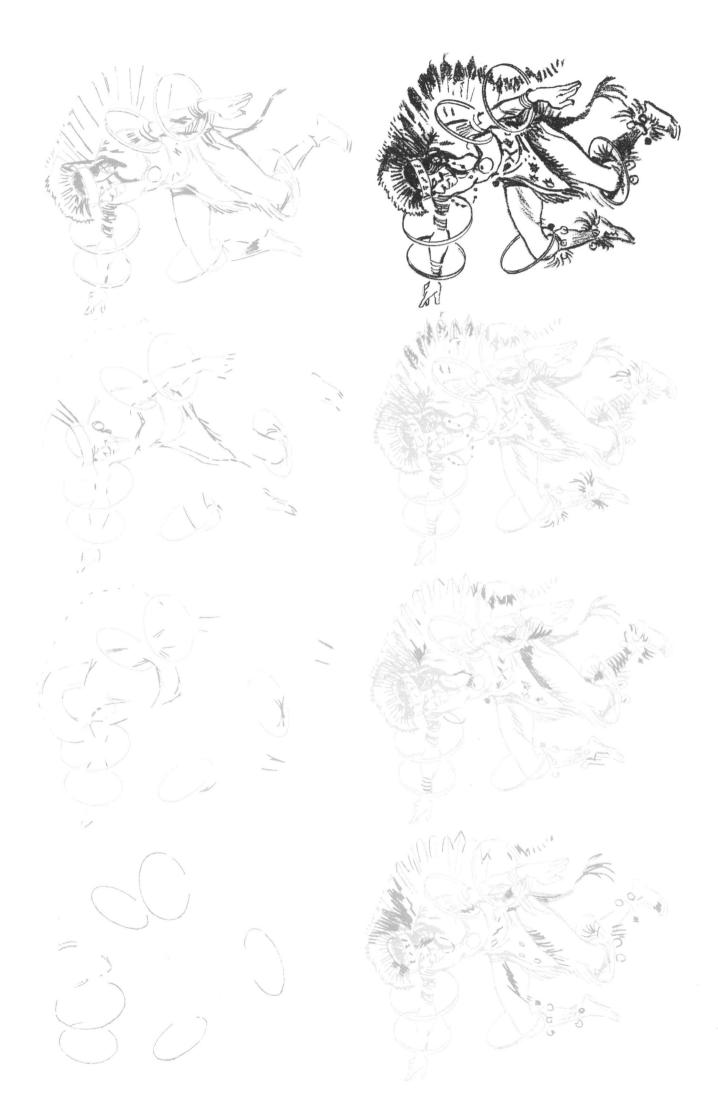

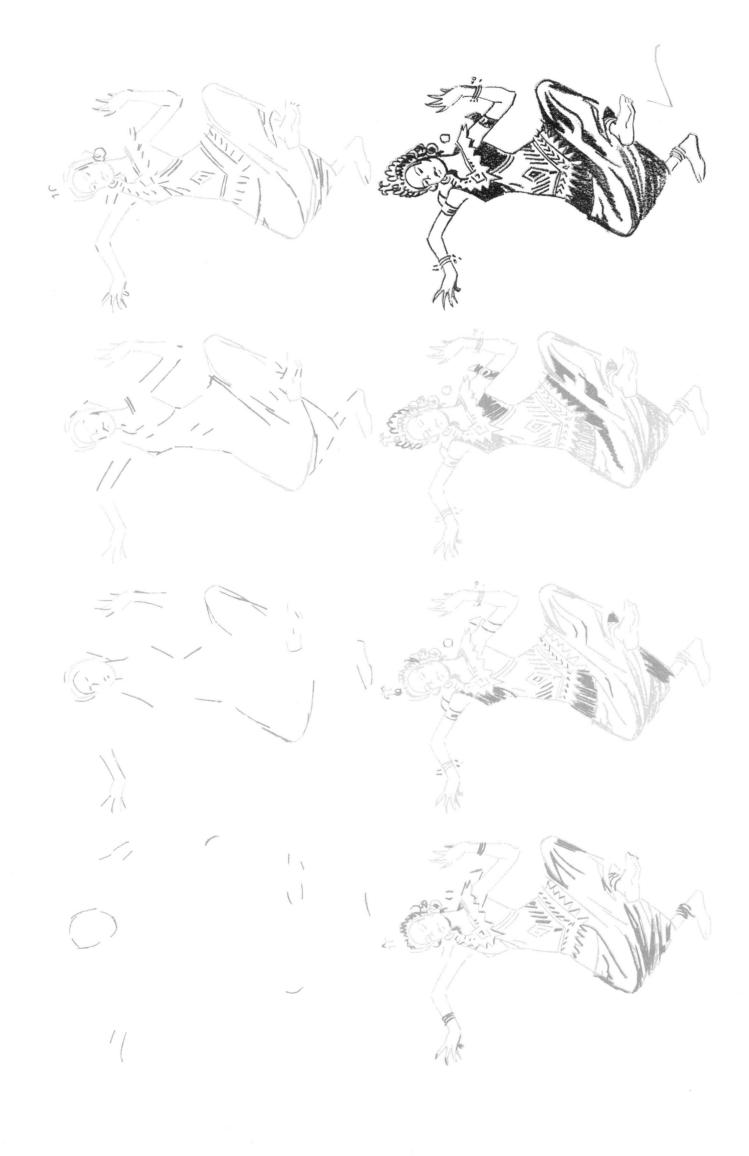

Lee J. Ames has been "drawing 50" since 1974, when the first Draw 50 title— Draw 50 Animals—was published. Since that time, Ames has taught millions of people to draw everything from dinosaurs and sharks to boats, buildings, and cars. There are currently twenty-two titles in the Draw 50 series, with over two million books sold.

A native of Huntington, New York, **Creig Flessel** is a graduate of the Grand Central Art School where he studied illustration with the legendary Harvey Dunn. Creig is the winner of the "Ink Pot" and the Silver T-Square awards, and has created illustrations for comic books, advertising, magazines, and text-books. Creig works in an attic-studio overlooking Long Island Sound.

DRAW 50 FOR HOURS OF FUN!

Using Lee J. Ames's proven, step-by-step method of drawing instruction you can easily learn to draw animals, monsters, airplanes, cars, sharks, buildings, dinosaurs, famous cartoons, and so much more! Millions of people have learned to draw by using the award-winning "Draw 50" technique. Now you can too!

COLLECT THE ENTIRE DRAW 50 SERIES!

The Draw 50 Series books are available from your local bookstore. You may also order direct (make a copy of this form to order). Titles are paperback, unless otherwise indicated.

SBN	TITLE	PRICE	QTY TOTAL
23629-8	Airplanes, Aircraft,	¢0.05/\$11.05.0cm	X =
05100	and Spacecraft	\$8.95/\$11.95 Can	X — = —
9519-2	Animals	\$8.95/\$11.95 Can	
24638-2	Athletes	\$8.95/\$11.95 Can	X
26767-3	Beasties and Yugglies and Turnover Uglies and Things That Go Bump in the Night	\$8.95/\$11.95 Can	X =
23630-1	Boats, Ships, Trucks and Trains	\$8.95/\$11.95 Can	X =
11777-2	Buildings and Other Structures	\$8.95/\$11.95 Can	X =
24639-0	Cars, Trucks, and Motorcycles	\$8.95/\$11.95 Can	X =
24640-4	Cats	\$8.95/\$11.95 Can	X =
12449-3	Creepy Crawlies	\$8.95/\$11.95 Can	X =
19520-6	Dinosaurs and Other Prehistoric Animals	\$8.95/\$11.95 Can	X =
23431-7	Dogs	\$8.95/\$11.95 Can	X =
46985-3	Endangered Animals	\$8.95/\$11.95 Can	X =
19521-4	Famous Cartoons	\$8.95/\$11.95 Can	X — = —
23432-5	Famous Faces	\$8.95/\$11.95 Can	X =
47150-5	Flowers, Trees, and Other Plants	\$8.95/\$11.95 Can	X =
26770-3	Holiday Decorations	\$8.95/\$11.95 Can	X =
17642-2	Horses	\$8.95/\$11.95 Can	X =
17639-2	Monsters	\$8.95/\$11.95 Can	X =
41194-4	People	\$8.95/\$11.95 Can	X =
47162-9	People of the Bible	\$8.95/\$11.95 Can	X =
47005-3	People of the Bible (hardcover)	\$13.95/\$19.95 Can	X —— = ———
26768-1	Sharks, Whales, and Other Sea Creatures	\$8.95/\$11.95 Can	X =
14154-8	Vehicles	\$8.95/\$11.95 Can	X =
	Shipping and handling	(add \$2.50 per order)	X =
		TOTAL	

Please send me the title(s) I have indicated above. I am enclosing \$
Send check or money order in U.S. funds only (no C.O.D.s or cash, please). Make check payable to
Doubleday Consumer Services. Allow 4 - 6 weeks for delivery.
Prices and availability are subject to change without notice.
, ,

Name:			-
Address:		Apt. #	_
City:	State:	ZIP Code:	

Send completed coupon and payment to:

Doubleday Consumer Services
Dept. LA 28
2451 South Wolf Road
Des Plaines, IL 60018